IMAGES
of America

BOLINAS AND STINSON BEACH

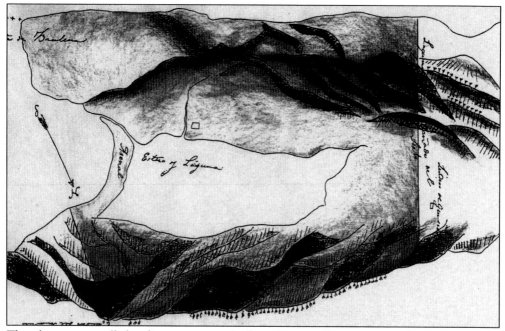

The above map, called a *diseño*, was attached to Gregorio Briones's appeal to the Mexican government for a grant of two square leagues of land in what is now western Marin. The Spanish words on the *diseño* identify several locations including "Estero y Laguna" on the lagoon, "Punta de Baulenes" on the point of land overlooking the reef, "Arenal" on the sandspit and "Lindaro del Sausalito" for the border of the Sausalito land grant of William Richardson, who drew the Briones map. The version of the *diseño* below is overlaid with the names of various locations as we know them today, including the road from Olema to Bolinas.

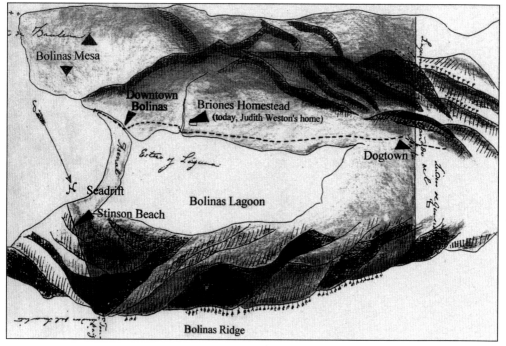

IMAGES
of America

BOLINAS AND STINSON BEACH

Phil Frank for the Bolinas Museum

Kendrick Rand and Tamae Agnoli for
the Stinson Beach Historical Society

ARCADIA

Published by Arcadia Publishing
Charleston SC, Chicago IL, Portsmouth NH, San Francisco CA

Printed in Great Britain

Library of Congress Catalog Card Number: 2004104892

For all general information contact Arcadia Publishing at:
Telephone 843-853-2070
Fax 843-853-0044
E-mail sales@arcadiapublishing.com
For customer service and orders:
Toll-Free 1-888-313-2665

Visit us on the internet at http://www.arcadiapublishing.com

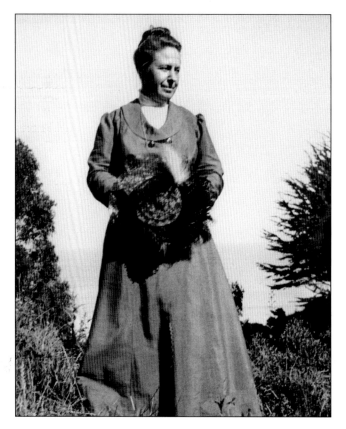

Gertrude Southworth, shown here in a rare appearance in front of the lens, is the woman who took many of the photographs in this collection, including the cover. Of the 500 Southworth negatives in the Bolinas Museum collection, she appears in fewer than 5 images. She used a Kodak folding camera and sent her film out for developing, but made her own prints.

CONTENTS

ACKNOWLEDGMENTS

The Bolinas Museum extends its thanks to Amy and Cyrus Harmon, who have funded the printing of the Southworth negatives over the last several years and have helped to underwrite the production costs of this book. The Bolinas Museum also wishes to thank the following: Joan Bertsch, Ralph and Terry Camiccia, Louise Pepper, Sarah Pusey, Piro Patton, Michelle de Greeve, Nancy and Herb Tully, and Dewey Livingston. We also wish to give posthumous thanks to historians Jack Mason and Tom Barfield whose publications and notes aided us in the production of this book. Author of the Bolinas section was Phil Frank.

The Stinson Beach Historical Society wishes to thank Janice Cline, president, and the board for their enthusiastic support of this project; Jane Slack, the first president of the Stinson Beach Historical Society, who laid the foundation; and Kendrick Rand and Tamae Agnoli for compiling this story. We also thank the tireless band of digitizers: Tamae Agnoli, Phyllis Fitzpatrick, Jan DeBeers, Barrie Stebbings, Shirley Moyce, Barbara Ward, and Georgia Heid. Kerry Livingston, our town librarian, was invaluable; and Karen Schaser was a typist extraordinaire. The historical society would also like to thank the late Louise Airey, the late Mildred Sadler, and the late Joan Reutinger.

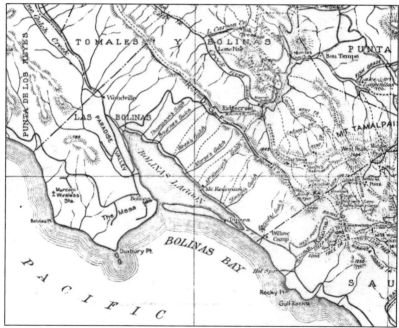

This road and trail map from 1908 shows Bolinas and Stinson Beach, sometimes called "The Lagoon Community." Notice Willow Camp (Stinson Beach) is included in the larger area of Bolinas. Both towns developed side by side sharing natural wealth as well as political and social ideas, facilities, like schools, and rescue operations. Note the Marconi Wireless Station on the Mesa of Bolinas, McKennan's Landing on the lagoon shore, Dipsea Inn on the sandspit, and Hot Spring to the south of Willow camp.

Part I
BOLINAS
LIFE ON THE EDGE

The area we know today as Bolinas, the very tail of the shifting plate that also created Tomales Bay and the Olema Valley, is a place separated by nature and mentality from the surrounding landscape. There is one road in and one road out. The ocean is on one side, a lagoon on another, and National Park everywhere else. There are no road signs to give direction; no services that cater to the visitor. There is a feeling of separation here from the pressure of society and the urban street.

This landscape was occupied for thousands of years by Coast Miwok natives who had no experience with the outside world until the 1500s, when European explorers first set foot on this soil. This land was once claimed by Mexico. It came as a surprise to the Miwok that they were suddenly tenants on their own land—tenants of people who did not speak their language.

The Mexican government gave 10,000 acres to one man, Gregorio Briones. He, like the Miwok, witnessed his pastoral landscape and lifestyle change suddenly. His nemesis would be the gold seekers and opportunists who did not speak his language. Over the years this huge holding, once encompassing both Bolinas and Stinson Beach, was cut into smaller and smaller parcels of land with more and more owners until this day, when an acre of property is considered sizeable.

Bolinas, though small, has had a large history because of its location, the drama of the sea, and the wealth of its fields and forests. This is the story of a small part of that history as told through the camera's eye and the words of its residents, past and present.

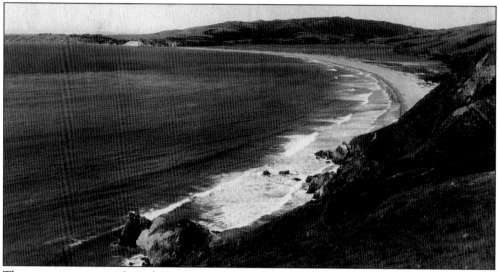

This panoramic image from the early 1900s captures the setting for this story and the sweeping scope of the landscape that has drawn residents and visitors alike to this area.

One
COAST MIWOK VILLAGE

The rich bottomland that is today's Gospel Flat, where four churches stood in the 1870s, was once a native village site, known in the language of those who dwelt here as Bauli-N. The Coast Miwok, who called this area home for approximately 3,000 years, were drawn to this landscape by its abundant shellfish and freshwater creek, which still runs through the former village site, to the lagoon.

They came also for the trade goods that would provide barter with the inland tribes who occupied areas where obsidian for spear, knife, and arrow points was available. Abalone shell, always in demand by inland tribes, was available nearby. But more importantly, there was a rare seep here where viscous asphaltum (a natural oil seep) bubbled to the surface of the land. The natives used this as a glue. With it, twine was adhered to rock, blade to hilt, feather to shaft and

ornaments to the bones of honored ancestors. With these trade goods the people of Bauli-N were guaranteed a secure future. And so they stayed.

The soil of Gospel Flat is rich for growing because of massive middens of seashell and enriched soil laid down by many centuries of native occupation. Arrow and spear points still surface in the tilled soil of Gospel Flat. The Bolinas Museum collection includes obsidian blades, charm stones, mortars, pestles, beads, fish hooks and ornaments that have sifted out of this landscape, witness to the natives' long presence.

The Coast Miwok, as a tribe, have gone from Bolinas, first taken by the soldiers to the missions where their families were decimated by the illnesses of the occupiers. By the time Gregorio Briones entered this landscape in the 1830s there were only a few natives remaining. But there are still Miwok among us, descendants of those who intermarried with the Mexicans and Europeans. Today's Miwok are scattered to other parts of Marin and Sonoma, no longer living tribally, but still a presence on the landscape.

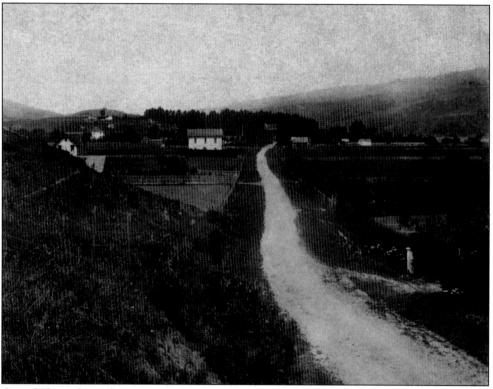

Gospel Flat is shown here c. 1900. This flat plain was the area occupied by the Coast Miwok for approximately 3,000 years. Gregorio and Ramona Briones made their home here too in the 1830s on the other side of the creek that first drew the Miwok to this site.

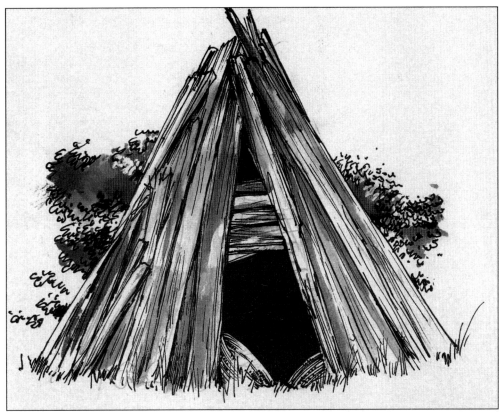

The Coast Miwok village site at Bauli-N resembled that of the Interior Miwok of Yosemite. There would be houses built of slabs of redwood bark arranged in a conical pattern as in this illustration. An entrance would be provided. There would be acorn granaries, cooking fires, and a sweat lodge. Between 75 and 200 individuals would occupy a village site.

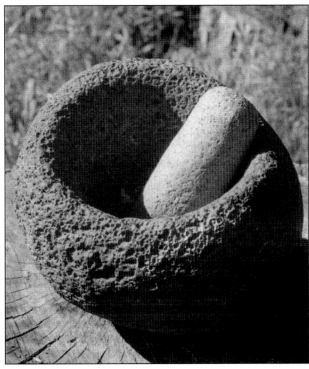

Mortars and pestles for crushing and mashing acorn meal still surface. Some mortars even have indentations for fingers and one in the Bolinas Museum collection was obviously owned by a left-handed individual. Acorns could be stored for up to two years in granaries raised on poles off the ground to prevent rodents from gaining access.

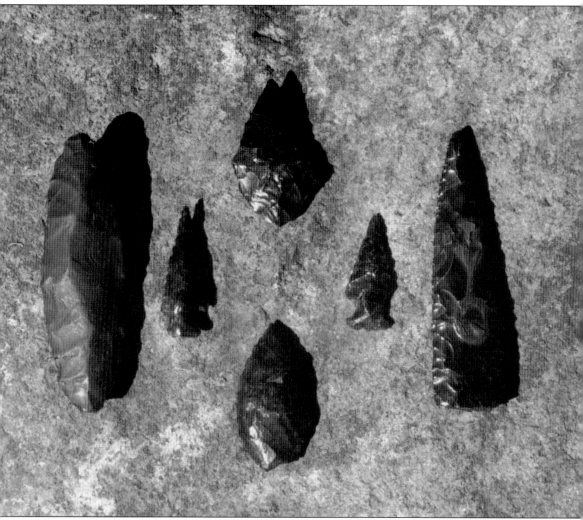

Obsidian points have surfaced at Gospel Flat over the years, either coincidental to the efforts of the plow or as the result of intentional digging. Arrow points are generally referred to as "bird points" if they are small and delicate. The next size up are atlatl points, which were attached to a small spear whose speed, accuracy, and range were aided by a throwing stick that would remain in the hunter's hand after the spear was launched. Spear points, knife blades, and skinning tools make up the majority of the other obsidian finds.

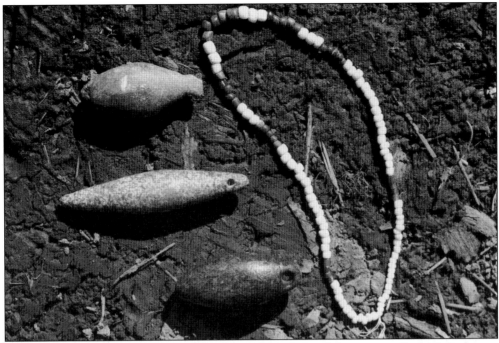

These shaped stones of granite, serpentine, and basalt are "charm stones" which had great symbolism to the native peoples. They were worn primarily by hunters who attached them to a leather or twine thong worn over their shoulders. They are believed to have been talismans to aid hunting and fertility. Trade beads, like the ones seen here, have also surfaced in archaeological digs in Marin County.

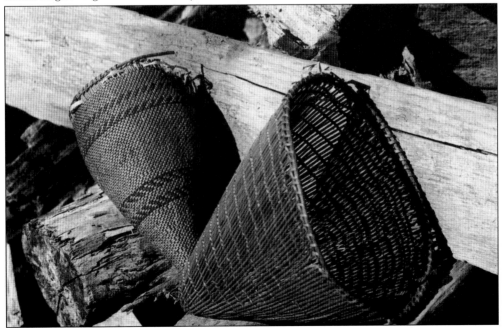

Baskets were used by the Coast Miwok for gathering acorns and cooking acorn mash. Cooking baskets were so tightly woven that they held water.

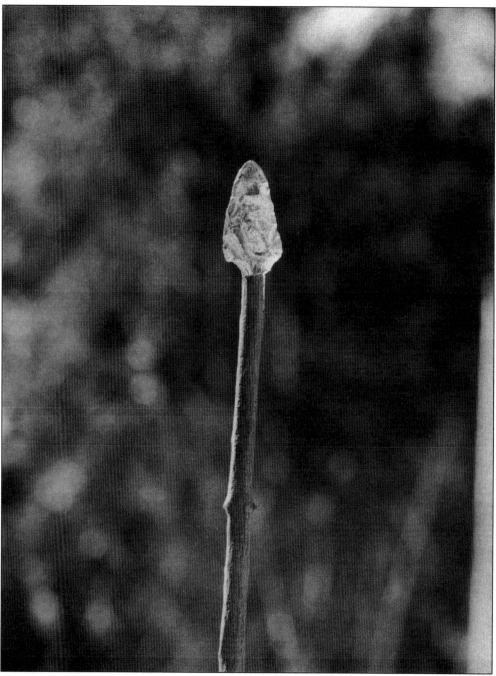

Most of the Native American artifacts in the Bolinas Museum's collection are gifts or loans from Gus Knowles and Russ Riviere. As a young boy in the 1940s Gus dug for artifacts in a former village site. Among the items he found was one point made not from obsidian, but from bottle glass. This suggests that the village site was still occupied after the arrival of Europeans and that the residents were still hunting game. We also know that the Coast Miwok acquired some metal and ceramic both from Sir Francis Drake and from the wreck of the *San Augustin* at Point Reyes in 1595, 16 years after Drake's visit.

Two

MEXICAN LAND GRANT

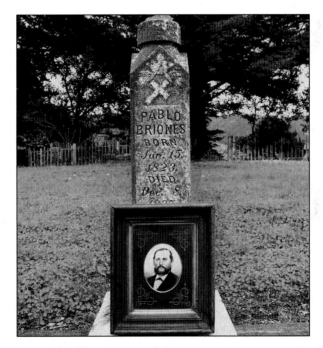

Gregorio Briones was a good soldier. He served the Mexican government loyally for many years and was respected by his compatriots. He had served as *alcalde* (mayor) at San Mateo, justice of the peace at the San Rafael settlement, and an officer at Yerba Buena, the area that would one day become San Francisco.

Gregorio earned his reward for twenty years of faithful service. He requested and was eventually granted roughly two leagues of land that encompassed a three by six mile section of western Marin. It included everything we know of today as Dogtown to Bolinas to Stinson Beach, up to Bolinas Ridge and down to the ocean. Shown also on the diseño, the map attached to the grant, is the "Arenal," the great sandspit known today as Seadrift. The land grant was called Rancho Baulenes.

Gregorio ensconced his son, Pablo, on the land in 1837 and brought the rest of his family in 1839. They ran cattle, planted orchards, and employed some of the remaining Miwok as workers. He and Ramona had five children—two sons and three daughters. They cultivated and tilled large fields, entertained visiting friends, and relished the lifestyle of wealthy landowners in one of the most magical landscapes imaginable.

They had nine wonderful years of tranquility. Then, it seemed that their world turned upside down. In nearby areas today known as Sonoma and Napa Counties, Mexicans were fighting Americans in the Bear Flag Rebellion. Gold was discovered in California. Strangers invaded Rancho Baulenes. Yerba Buena grew by 40,000 residents in one year and became San Francisco. Statehood was declared. Suddenly Gregorio Briones had to defend his hard-won land grant in the American courts. It cost him a third of his land to defend his title and then he was given tax bills for the remaining property.

Entrepreneurs, prospectors, and homesteaders arrived. Suddenly Don Gregorio Briones's compound was referred to by newly-arrived fortune seekers as "Greaserville," and his daughters were courted by Yankees. It was more than he could bear. He died in May of 1863 and was buried not in the little graveyard on his Bolinas land, but at Mission Dolores in San Francisco. His memories of an earlier, simpler time were buried with him.

The 1849 home of the Briones family, still used as a residence today, forms the backdrop for one of the family's albums from the 1800s.

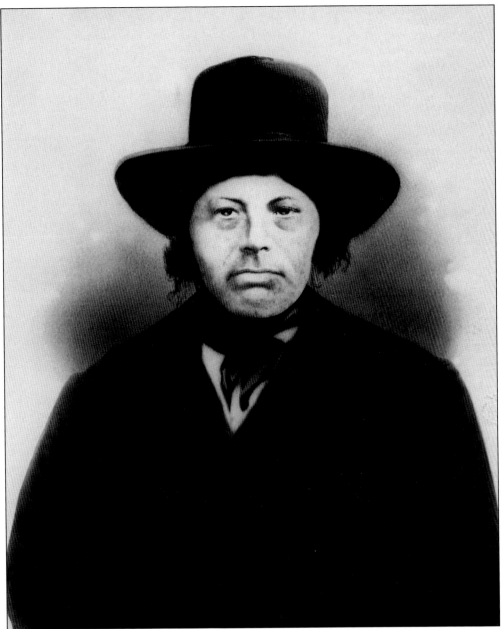

This is the only image of Gregorio Briones in the collection of the Bolinas Museum. He was not enamored with the Americans who flooded the area in the 1850s. He never bothered to learn English. His Bible was in Spanish, as was his will. We have no first-hand information about Gregorio, but descriptions passed down through members of the family to recent times describe him as a caring father and a friend to all within his circle of contacts. Rumors that he was poisoned by one of his Indian helpers before his death in May of 1863 have been consistently denied by his descendants. Gregorio forbade his three daughters to marry the American suitors who came calling. They obeyed and married Mexican men. However after Gregorio's death, all three remarried Americans, two when their first husbands died, one after she divorced her first husband.

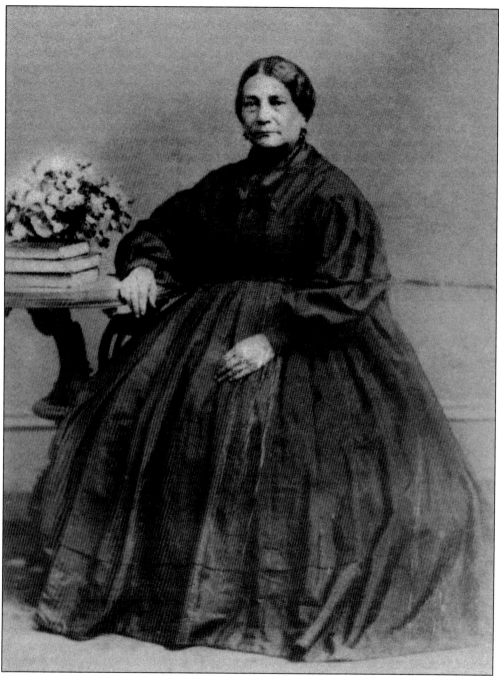

Ramona Briones, grand dame of the Briones family, is seen here in an early portrait. She and Gregorio married at Mission Dolores in 1822. She was the matriarch of the hacienda with its five children, several foster children, and a number of native "retainers" who helped in the fields and around the home. When Gregorio died in 1863, Ramona mourned for a short while and then remarried a Chilean, Benancha Munos. Apparently the union was against her family's wishes, and Ramona became somewhat estranged from the rest of the Briones family. She died in 1901 at 99 years of age.

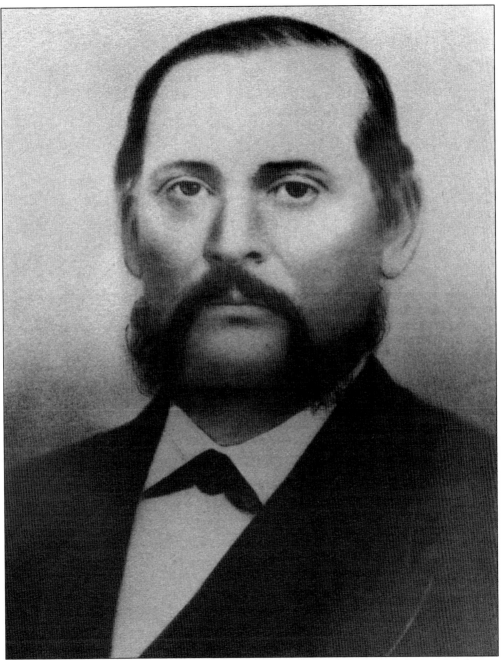

Pablo Briones, the eldest son of Gregorio and Ramona, differed from his father in that he got along well with the newly arrived Anglos. He had been trained as a youth in the medical arts by his paternal aunt, Juana Briones. Juana was a well-respected healer in Yerba Buena, later known as San Francisco. Pablo was famous for his knowledge of medicinal herbs and his ability to set bones. He even had a medical license, issued by the Internal Revenue Service for $10. Pablo made his home at the northern border of Rancho Baulenes. That area became known as Dogtown because of the many dogs owned by commercial hunters. Pablo married Rafaela Santilla and they had eight children.

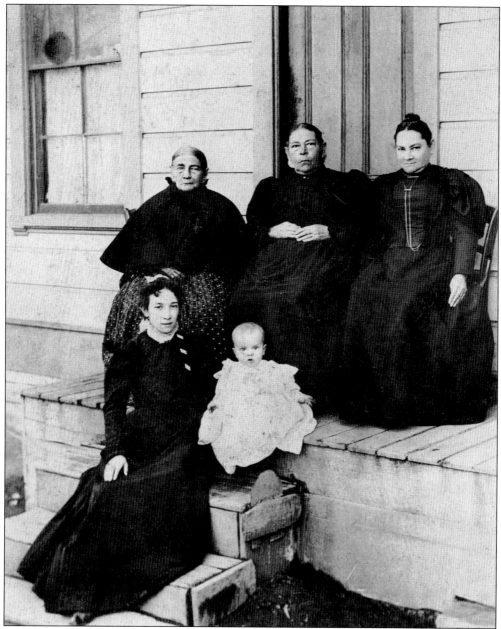

This classic photograph encompasses five generations of Briones women. From left to right at the top are Ramona Garcia Briones Munos (wife of Gregorio), her daughter Maria del Rosario Briones (Mrs. Francisca Mesa), and her daughter Francisca Nott (Mrs. Samuel Clark). On the steps are Francisco's daughter Frances Clark (Mrs. Martin McGovern) and her daughter Elcy McGovern. A little known fact is that there are actually six women present. Young Frances Clark McGovern is pregnant with a second daughter.

Rose Briones, pictured here against a backdrop of Briones documents, was the youngest daughter of Pablo and Rafaella. She was the last surviving member of the immediate family. Born in 1882, she lived her entire life in the Bolinas area and never married. She became caretaker of the family records, and when she died in 1983 at 101 years of age, the little Dogtown schoolhouse where she lived was sold. The new owners found many documents, some singed by fires, and donated them to the Bolinas Museum.

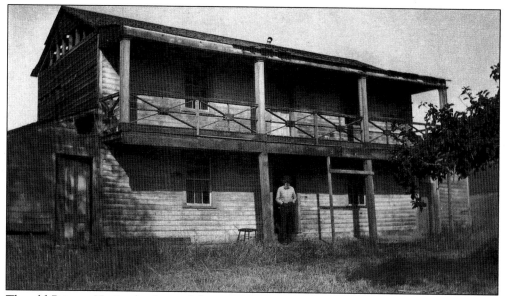

The old Briones Hacienda, deserted for many years, is seen in this early 1900s photograph by Gertrude Southworth. Don Pedro Garcia, whose father, Rafael, was Ramona Briones's brother, stands in the doorway of the old house. Pedro was a famous rodeo rider in his day and stopped by often to stay in the old house.

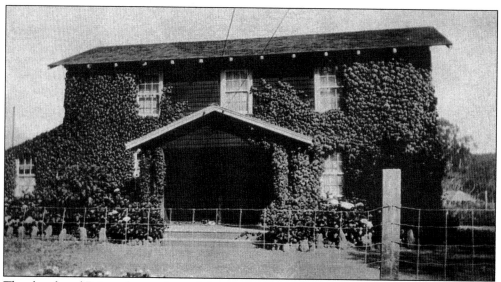

The abandoned Briones house pictured above received a new lease on life when the Miller family purchased the property in 1912. By that time, cattle were wandering through the old home. The Millers went to work and repaired and restored Gregorio and Ramona's former home. It stayed in the Miller family until its sale to Judith Weston, who currently owns the property.

Three
BOOM AND BUST

The drama of the Bear Flag Rebellion, the discovery of gold, and California statehood had all come to pass by 1852, when Marin County had its first census. The results showed that 323 adults were living in Marin. Of that number, two-thirds lived in Bolinas Township, which says something about its importance at that time.

This was an area where things were happening. San Francisco could not be built, or rebuilt, each time it burned, unless there was lumber. Construction lumber was worth $2 a foot at the San Francisco piers. Gregorio Briones had redwood trees at Rancho Baulenes and he signed contracts with loggers to fell them. The first contracts allowed Briones to build a home in exchange for the right to cut timber. Several mills were built in Dogtown and others were built on Bolinas Ridge where trees were being toppled.

Lumberjacks poured into the area and lumber poured out—13,000,000 board feet over the years, to help build San Francisco. To get the goods to market required boats—schooners to be specific. Many first-growth redwoods went to San Francisco as pier pilings, towed behind schooners as huge rafts. Between 1850 and 1900 a dozen schooners were built in Bolinas lagoon, most by the Johnson brothers.

Fortune seekers who weren't cutting wood prospected in West Marin and found what they were looking for—oil, gold, copper, and coal—not enough to make them rich, but enough to keep folks looking. In the 1930s there was even a rush on ambergris, a by-product of the sperm whale used to make perfume.

During Prohibition (1919 to 1934) most of the illegal booze that reached San Francisco bars came through Marin. It came ashore by way of fast rumrunner boats, picking up loads from Canadian and Mexican "mother ships" lying offshore. The bootleg was loaded onto trucks and driven to Sausalito and then onto late-night ferries headed for San Francisco. More than a few Bolinas residents put food on their tables and drink in their cupboards this way during those lean years.

Before the arrival of the motor car and good roads, all cut wood was transported by schooners out of Bolinas, while open barges known as lighters, filled with firewood for heating and cooking, were towed over the bar by gas-powered craft. Four hundred cords of wood were shipped every week. Dairy products, beef, venison, and duck and chicken eggs from West Marin filled San Francisco's market baskets and brought a level of wealth and prestige to this little harbor town perched on the edge of the continent.

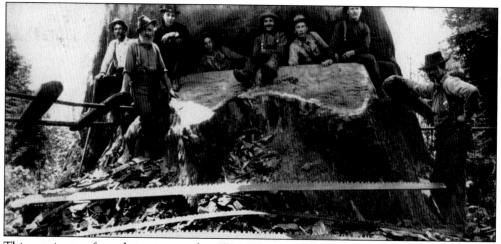

This rare image of woodcutters at work in West Marin near Gregorio's Creek gives some idea of the size of the redwoods that once grew in the Dogtown area up to Bolinas Ridge. The large redwood trunks would be pulled by oxen to the mills. Smaller redwood logs, to be used for wharf pilings, would be dragged to the shore of the lagoon where they would form rafts to be floated to San Francisco.

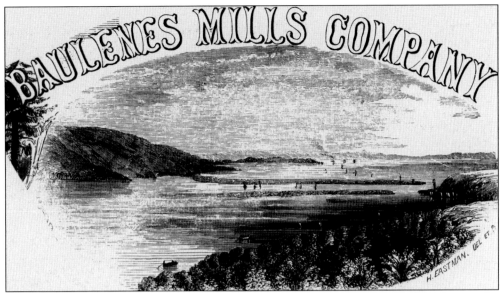

This logo for one of the saw mills operating in Dogtown uses the same spelling of Bolinas as the original Mexican land grant, and dates to the 1850s. The engraving shows the *arenal*, the sandspit that is today's Seadrift, and even Kent Island in its formative stages.

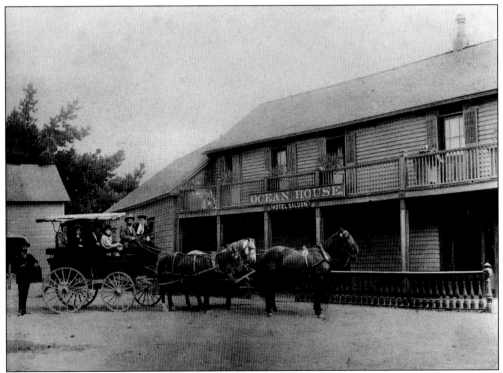

The first hotel in Bolinas, built by George Gavitt in 1853, is shown here, It also had a wharf and a saloon. Bolinas was touted as a seaside escape from the summer heat of the Central Valley. People came. The rates were $12 a week, half rate for children. The Ocean House was later renamed the Flag Staff Inn.

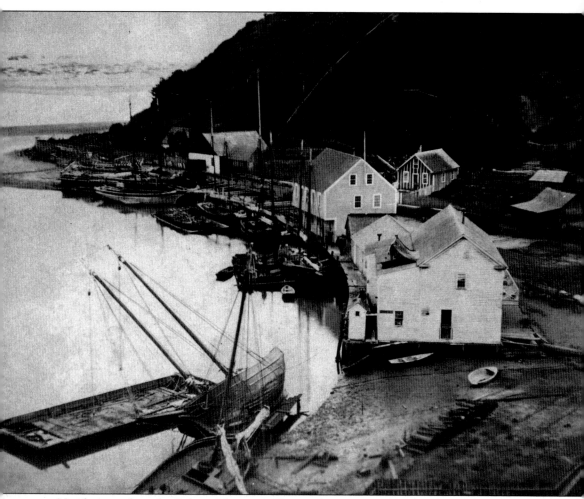

No photograph in the Bolinas Museum collection better encapsulates Bolinas as a trade center than this image from 1873. In all, six schooners, the workhorses of the Bolinas-to-San Francisco run, can be seen in this image. Another is under construction on land at the far end of the line of boats. Two lighters, or open barges, are in the process of being loaded with cordwood, while another, empty, awaits its cargo. One schooner in the foreground is careened, or laid over, for hull repairs, and on the roadway an ox cart that has hauled cordwood to the docks, waits. The two hotels are completed and accepting guests, although the large addition to the Flag Staff Inn has yet to be built. In the background, around the corner and beyond the bar, the ocean rages, while here, inside the bar, the water is calm enough to create a reflection of the ships.

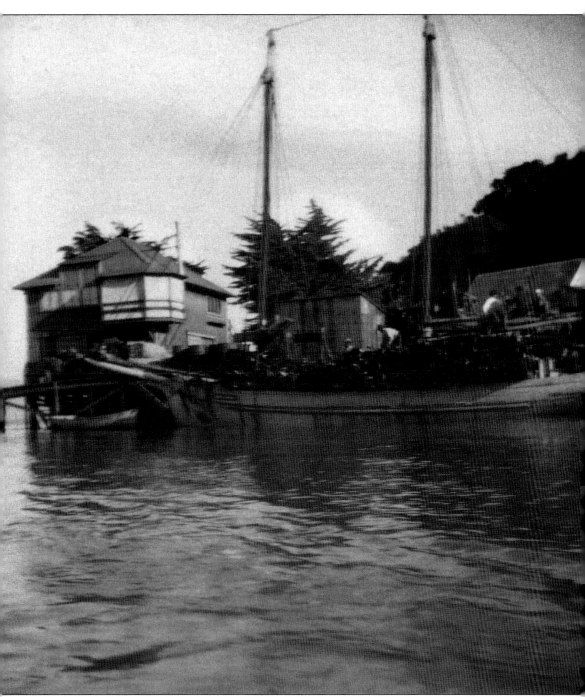

Cordwood headed for San Francisco is being loaded aboard a schooner beside the Waterhouse Wharf. After most of the good construction lumber was cut in Dogtown and on the Bolinas Ridge, supplying urban centers with firewood became the lumbermen's next venture.

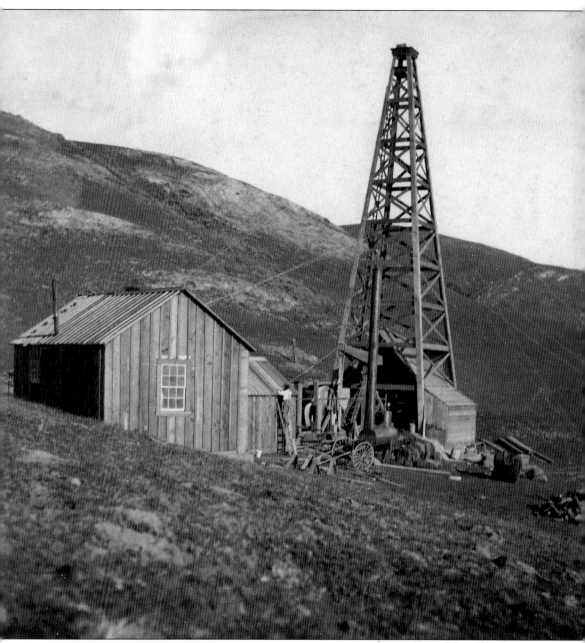

Is there oil in Bolinas? Here is the proof. There was only one well, and the poor quality of its product made it useless. But according to reports, oil that was brought up was put back into the well and pumped out again for unsuspecting investors, and there were more than a few. The excitement of a potential oil boom in Bolinas caused William Lacey to rename his hotel The Petroleum.

This early dairy ranching photo is believed to be of the Nott Ranch on Mesa Road and gives an idea of the daily operations of a dairy in the 1800s. Three milkers, two with buckets, do their work outdoors rather than in the barn.

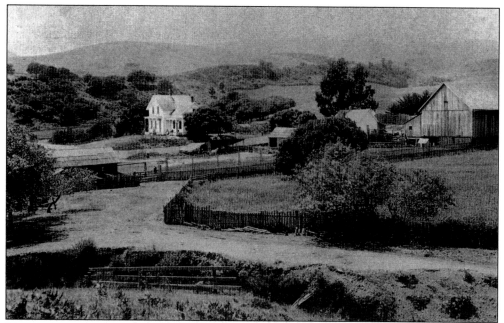

This is a portrait of the W.W. Wilkins ranch about 1880. Wilkins and his family ran the dairy ranch for nearly 100 years. High property taxes resulted in its sale, and shortly thereafter it passed into the hands of the National Park Service. The NPS has invested a great deal of money to save the old dairy barn, originally built by Capt. Isaac Morgan shortly after he purchased the land from Gregorio Briones in 1852. Part of the barn's undersupports are masts and timbers from old ships. The ranch sits at the intersection known as the Bolinas Wye, a striking image on the pastoral landscape.

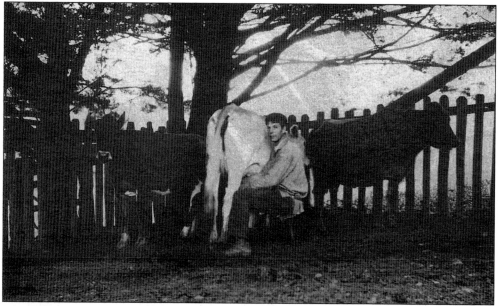

Jim Wilkins is seen here milking two dairy cows on the family ranch in 1901. Jim, son of William Wilkins, lived his entire life on the ranch at the head of Bolinas Lagoon and ran the dairy after his father died in 1910.

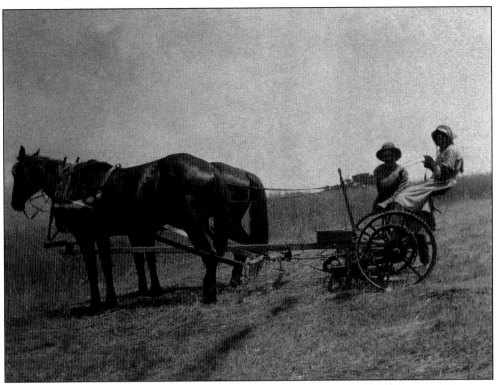

This photo captures haying operations on Horseshoe Hill. The Mazotti family stops to pose during the harvest season about 1900. Extra hands were often hired at local ranches to help cut and store the winter feed for cattle and dairy cows.

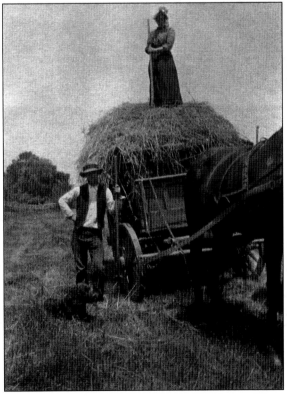

Many Bolinas residents who grew up on ranches fondly recall the haying season as a family operation that allowed children to take part in a ranching activity that they would long remember.

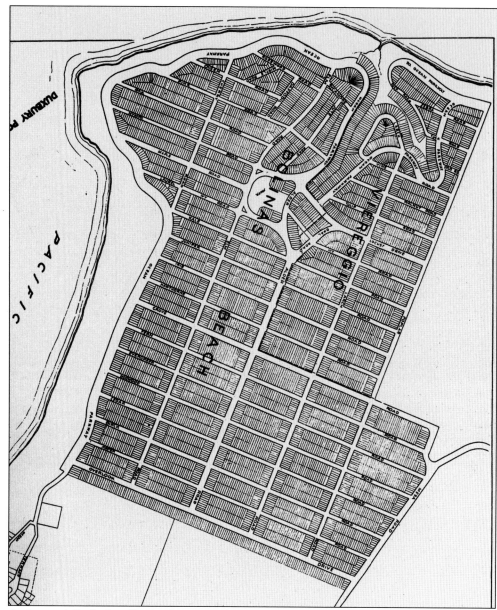

Arthur and Ruth Smadbeck of New York City filed a subdivision map with the County of Marin in April 1927 to develop the "big mesa" into Bolinas Beach. In all, there were 5,336 lots, each 20 by 100 feet. Shortly thereafter, the *San Francisco Bulletin* began offering a 20-foot-wide lot at Bolinas Beach for $69.50 to all new subscribers.

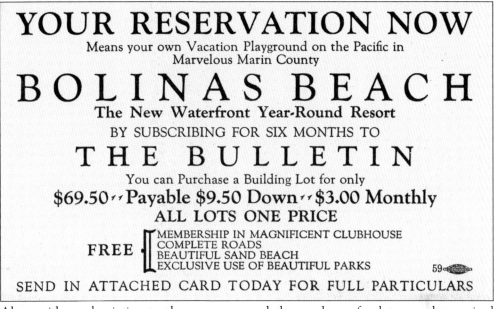

YOUR RESERVATION NOW

Means your own Vacation Playground on the Pacific in
Marvelous Marin County

BOLINAS BEACH

The New Waterfront Year-Round Resort

BY SUBSCRIBING FOR SIX MONTHS TO

THE BULLETIN

You can Purchase a Building Lot for only

$69.50 ·· Payable $9.50 Down ·· $3.00 Monthly

ALL LOTS ONE PRICE

FREE {
MEMBERSHIP IN MAGNIFICENT CLUBHOUSE
COMPLETE ROADS
BEAUTIFUL SAND BEACH
EXCLUSIVE USE OF BEAUTIFUL PARKS

59

SEND IN ATTACHED CARD TODAY FOR FULL PARTICULARS

Along with a subscription to the newspaper and the purchase of a lot, a reader received membership in the clubhouse pictured here below. Few lots sold and *The Bulletin* pulled out of the scheme shortly after. The narrow lots were barely buildable, and owners found it necessary to buy several in order to create a decent-sized construction site. Eventually the "clubhouse" became the BPUD (Bolinas Public Utility District) building and the water moratorium eventually caused most of the area to be left vacant.

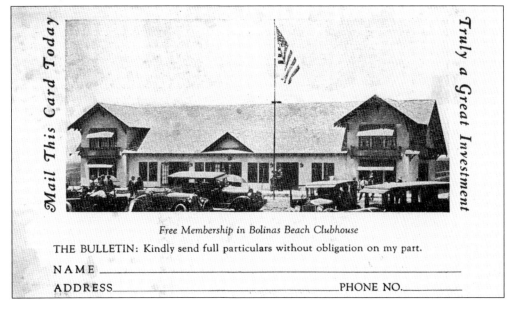

Free Membership in Bolinas Beach Clubhouse

THE BULLETIN: Kindly send full particulars without obligation on my part.

NAME _____

ADDRESS_____PHONE NO._____

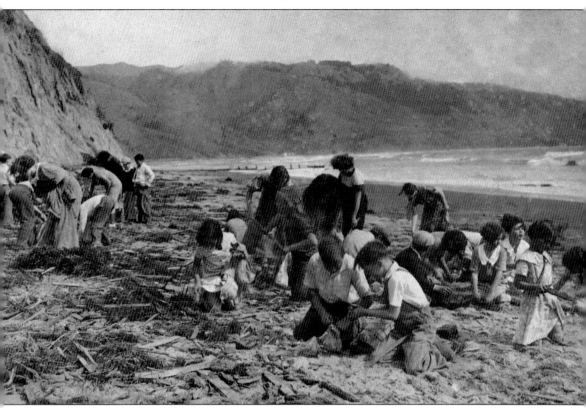

No story of Bolinas dreams of wealth can be told without mentioning the great "Ambergris Rush" of 1934. Ambergris, a secretion of the sperm whale used in the manufacture of perfume, and worth about $600 a pound, was thought to have been found on Bolinas Beach. School was let out so that students might search for the substance. As word got out, hundreds of people invaded the beaches searching for the smelly product. The Bourne boys acquired a stash of nearly $25,000 worth of ambergris and guarded it at gunpoint in a locked closet.

JUST AMBERGRIST FOR THE ARTISTIC MILL

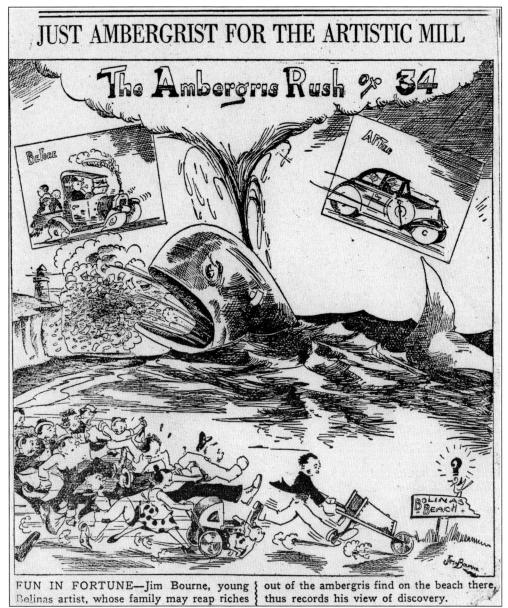

FUN IN FORTUNE—Jim Bourne, young Bolinas artist, whose family may reap riches out of the ambergris find on the beach there, thus records his view of discovery.

Jim Bourne, a young Bolinas artist, drew this cartoon of the ambergris rush for a San Francisco newspaper. It captured the residents' yearning for riches in the midst of the Great Depression. Initial tests on the material declared it the real thing, but in the end it turned out to be just "sewer butter," gelatinous sludge from the Oakland sewer system.

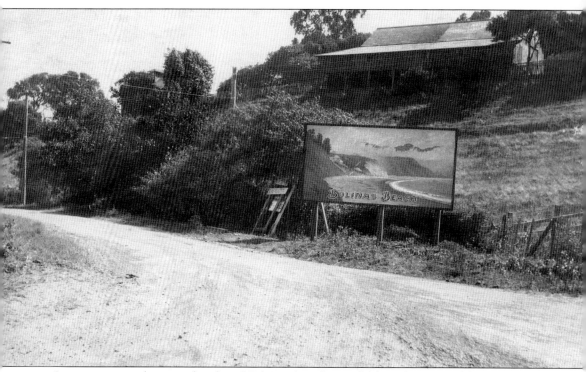

In an attempt to lure travelers from Highway 1 to the available real estate and beautiful sandy beaches, landscape painter Jack Wisby was commissioned to create a billboard. This was the result—a 17-foot-long oil painting of the beach and cliffs with "Bolinas Beach" emblazoned across it. It stood at the Bolinas Wye intersection for a number of years. An enduring question in Bolinas for years was: "Whatever happened to the big Wisby painting?" Here is the definitive answer: Amy Jordan, longtime summer and weekend resident, reported that in the 1930s, when she and a girlfriend were visiting at the Oyster House restaurant next door to the location of the sign, they noticed that the Bolinas Beach painting was being used as a loading ramp for the restaurant. They asked if it was available for purchase. The owner said, "Sure, for $75." The girls stared at each other and thought: "Who has $75?" So there it stayed—the loading ramp for the Oyster House until the eatery was torn down.

Four

BUILDING BOLINAS

For many years Bolinas was an area rather than a town. It only began to take on the semblance of a village when lumberjacks arrived along with seamen who would portage the cut lumber to market. These men needed places to sleep, to eat, and to drink. Thus Bolinas was born. Until then, the land belonged to the Briones clan and to a small number of ranchers, some who had married into the Briones family and some who had purchased sizeable plots from Gregorio Briones.

A bar was built in 1852; another in 1853. Within a few years there were four bars and a gaming room, and the area was justifiably called Jugville. Then a rooming house was built. Eventually a store, hotels, piers, schools, and churches appeared, making Bolinas much like many western towns. The hotels attracted escapees from the sizzling Central Valley summer

heat. Soon Bolinas became a destination.

The only thing not available was a single house lot, where one might build a home. There were businesses on small plots and there were large ranches of many acres, and that was about it. It took an entrepreneurial visitor in the late 1870s to recognize the need and come up with a solution: buy a ranch and subdivide it. The visitor's name was Frank Waterhouse. At that time the Pepper family carried out most of the construction in town. Eventually the two families merged when Marin Waterhouse married Lewis Pepper, and together they produced a brood of nine little Peppers.

The telephone arrived in 1885. It had only two customers for many years. Electricity did not arrive until 1914. A volunteer fire department was formed. A utility district with an office and staff was created. Incorporation was considered once but the idea was quickly tabled. Bolinas has had its sleepy periods over the decades. It became a seasonal village of sorts with a high influx of "summer folk" from the 1920s to the 1960s, and the beach was a natural attraction for urban families.

The sleepy times are over for Bolinas. Now it is a busy, active community that also manages to maintain a feeling of separation from the urban scene. Few residents commute to the city. Real estate is expensive now and will probably remain so. Occasionally a house slips off a cliff or burns and a new one is built, but there is no building boom here. Due to the water moratorium, the last available water meter sold for $250,000 in 2002.

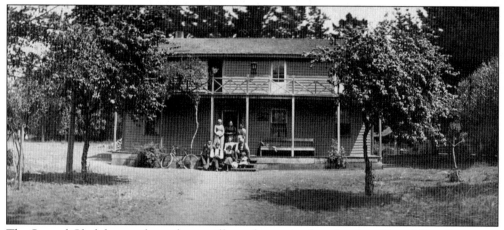

The Samuel Clark house, shown here, still stands next to the school on Gospel Flat. It was not built in this location but was moved to this spot from the Grinter brothers' property at the foot of Francisco Mesa in the 1860s. Originally it served as a rooming house, probably for lumberjacks. Note the numerous doors on the second floor.

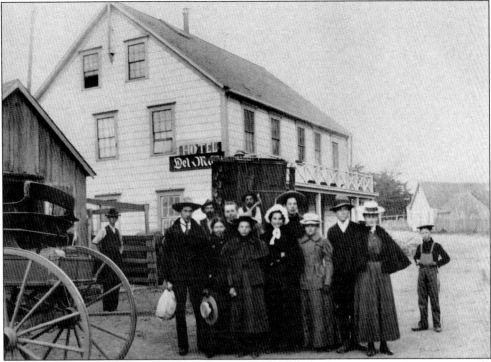

Guests pose in front of the Hotel Del Mar, the former Bolinas Tavern, about 1900. There had been rumors rampant for several years that the railroad would descend from Mount Tamalpais to the sandspit and then to Bolinas. These rumors fueled the construction of lodging facilities in the little town. Although the roadbed construction did actually begin, the train fantasy died shortly before the 1906 earthquake.

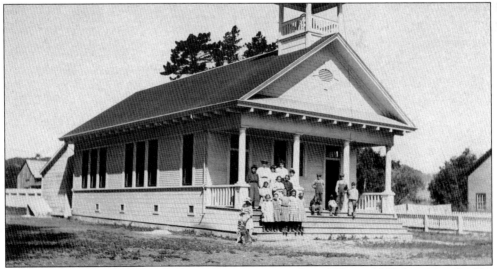

The Bay View School was first built on its present site at Gospel Flat in 1867. It was wrecked by the 1906 earthquake and rebuilt in 1908, when Gladys Hoagland was the teacher at $70 a month. This photograph, c. 1910, shows the structure much as it appears today. An arsonist nearly destroyed the building in the 1970s, but it was rebuilt along the original lines.

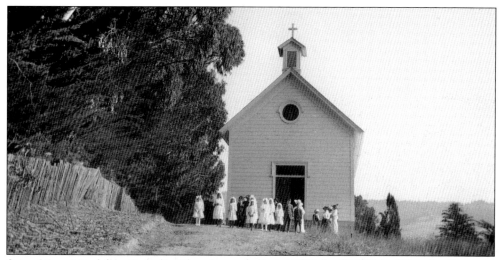

Saint Mary Magdalen Catholic Church was built in 1877 for $2,000 by Timothy Phinney, chicken farmer and coffin maker. Gregorio Briones willed the land to the church upon his death in 1863. The church has always been a mission church, without a resident pastor. Priests from neighboring communities were assigned to say mass on Sundays. When this Southworth portrait of a First Communion class was taken in 1911, Father Valentini of St. Mary Star of the Sea Church in Sausalito was still pastor. Every Sunday for 20 years Father Valentini, after saying the 7 a.m. mass in Sausalito, would ride his horse 17 miles out to Bolinas to say the 11 a.m. mass in this church.

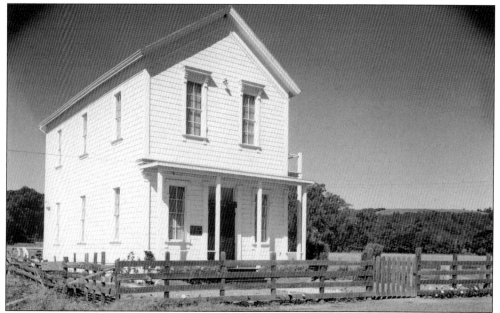

The Druids Hall on Gospel Flat seems to stand proudly for its 1940s portrait by Jim Foley. The United Ancient Order of Druids, Duxbury Grove No. 26, received its charter on June 5, 1875. The dedication ball for the new building on September 25, 1879, featured a recitation penned especially for the occasion by Druid George W. Peckham, "blacksmith poet." It drew outbursts of applause. The structure later became a Christian Science Church, was eventually deactivated, and later sold. Today it serves as a private home.

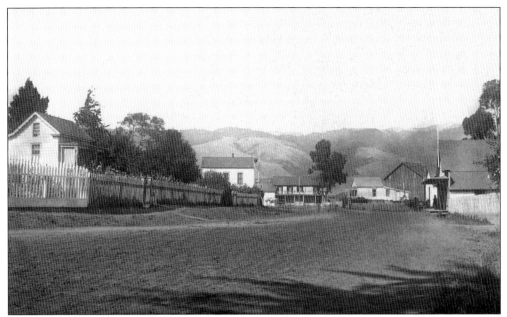

By the 1870s, Bolinas had its hotels in place, an active shipping operation, several saloons, a mercantile, a meat market and a downtown of sorts. Most of the families in the area were cattle and dairy ranchers. There were three churches, the Druids Hall, and the Bay View School on Gospel Flat. Clearly, this photograph was taken on a quiet day.

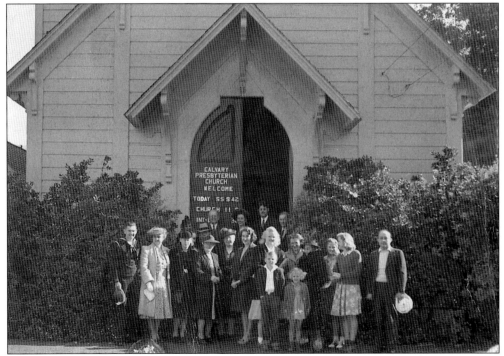

Calvary Presbyterian Church, built in 1877, has been a mainstay of the community for years. Originally located at Gospel Flat, it was moved to its current location on Brighton Avenue in 1898 and the belfry was added shortly after. This photograph was taken in 1940s.

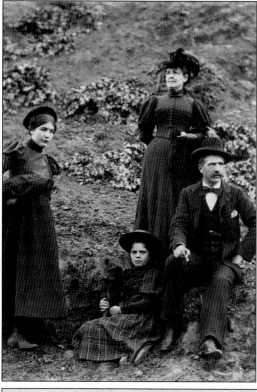

This is a portrait of the Waterhouse clan, plus one, memorializing the dour developer, Frank Waterhouse, who created the Brighton Avenue home sites. Behind him stands the more sociable Nellie Esten Waterhouse, whose artist studio still graces Wharf Road. Young Marin Waterhouse, who would remain a mainstay of the community for seventy years, stands at the left while her friend Muriel Hamm, seated beside Frank, contemplates the camera. Frank Waterhouse was an entrepreneur of the first order, investing in whatever was likely to turn a profit. He joined forces with his brother, who had invented an arc lamp for street lighting, to market the financially profitable product back east. Besides creating the Granda Vista subdivision, he built a warehouse and operated the mercantile. Frank even owned the telephone company in Tonopah, Nevada.

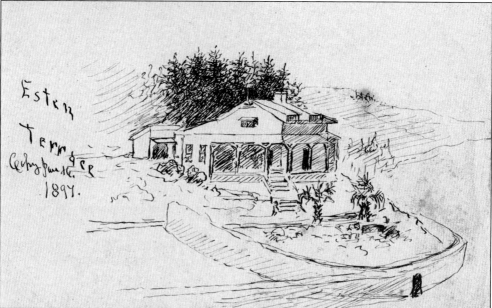

This pen and ink sketch of the Waterhouse residence was made by Nellie in 1897. They named the home Esten Terrace in honor of her parents, John and Rebecca Esten, who resided in Bolinas in the 1870s. It was while on a visit with his in-laws in 1879 that Frank Waterhouse tried unsuccessfully to purchase a home site. Instead, he purchased the 132-acre Briones Dairy ranch and subdivided it, creating 64 home sites.

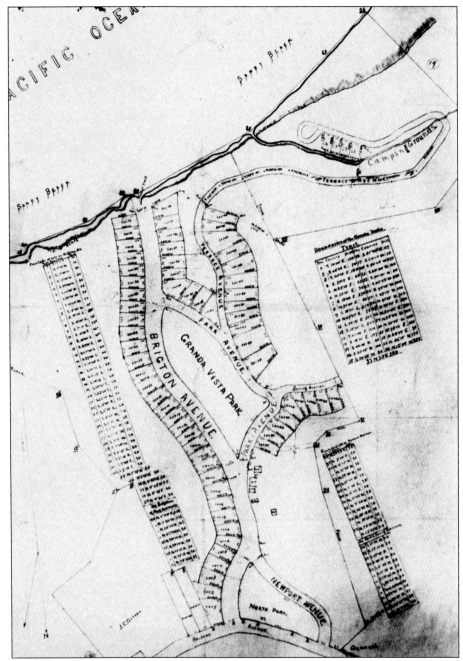

Shown here is the plat map for "Granda Vista" subdivision as surveyed by Hiram Austin in 1882. The average price was $500 for a 50-foot lot. The map outlined two parks, one called Granda Vista Park and the other North Park. The tennis courts are now located at the Granda Vista site. North Park, where the Bolinas Bay Lumber company is located today, apparently never got that swing set. Spring Avenue and Newport Avenue were never built. Frank had his rules, for Granda Vista was a gated community with an actual gate that closed off access to the area, just past the Presbyterian Church. Only property owners or guests were allowed to enter. This was done to control "raucous picnickers," but the gate didn't last long.

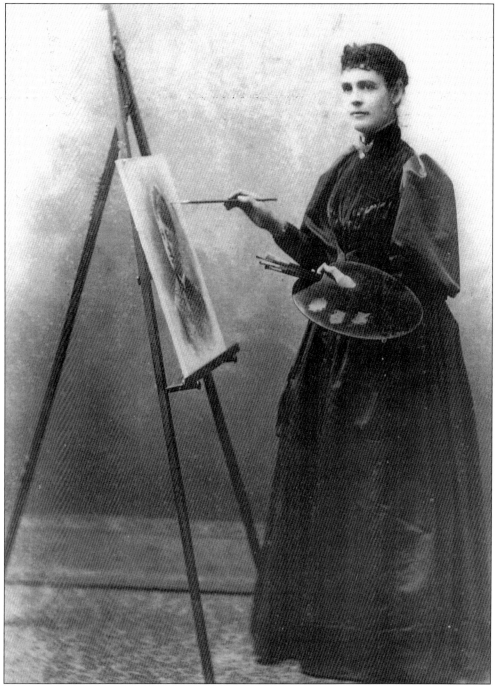

Nellie Waterhouse is pictured here as an art student in the late 1870s. Nellie's work had a naive quality, hardly the deft hand of Ludmilla and Thad Welch, good friends and fellow plein air (outdoor) painters who lived in a cabin in Steep Ravine, above Stinson Beach. Nellie painted for the love of art and relished her friendships with other artists, including Jack and Mary Wisby, who lived atop Little Mesa in Bolinas. Everyone was welcome at Nellie's Wharf Road studio and many artists, dignitaries, and townspeople came calling.

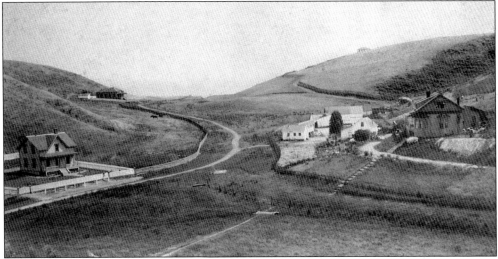

This 1884 image of Brighton Avenue shows the two-year old subdivision that was created from the 132-acre Jose Jesus Briones dairy ranch. The home on the far right was the Frank and Nellie Waterhouse residence. To the left of their home is the lower ranch of the Briones Dairy, the site of today's Waterhouse Building. Across the road in the distance is the John Lucas family home and in the left foreground is Capt. Peter Anderson's residence.

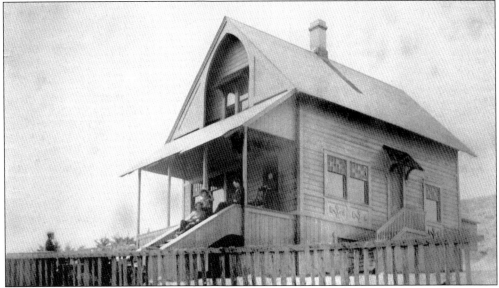

"The Camp," as it was affectionately known, was the summer and holiday home of the wealthy San Rafael dentist, Dr. Stephen Southworth and his family. It was one of the first residences built on Terrace Avenue. It remains today nearly identical to this 1890 photograph. At the turn of the century Dr. Southworth's wife hired a young Englishwoman to help care for the aging dentist. Gertrude Rice-Coles became a part of the family, traveling often with them to Bolinas. When Mrs. Southworth became ill and died, Gertrude continued to care for the doctor and eventually became the new Mrs. Southworth. She and the doctor lived happily together for 32 years until his death in the 1930s. Gertrude was a big fan of the new Kodak camera and quickly became the unofficial Bolinas photographer. Nearly every home in the little town had a Southworth photo print.

Wharf Road, also known as the Embarcadero, is still unpaved in this 1914 photograph of the newly-completed Coast Guard building, its landscaping not yet installed.

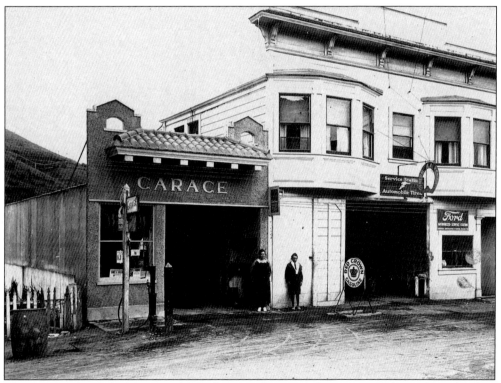

The Longley family had long-established ties to the garage location in Bolinas, from the days when Oliver Longley, the blacksmith, shoed horses and worked on carriages at this site. The carriage shop gave way to the residential and blacksmith shop on the right. Later, with the arrival of the automobile, the garage structure on the left was added, along with the gasoline pump. But the blacksmith sign remained.

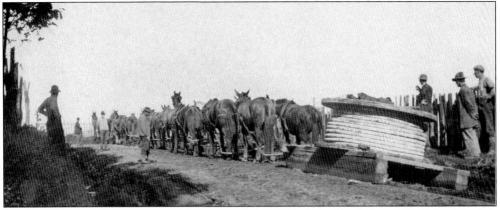

In 1913 two major events took place in Bolinas. The first was the arrival of the Marconi Wireless Telegraph Company, which purchased a large section of land to build a transmitting station on the mesa. The second was the actual construction of the facility in this somewhat remote location, and what that meant to the locals was business for the shops and jobs for residents, but most importantly it meant that electricity was coming to town. Giant pilings for the transmitting towers were floated to Bolinas by barge, reels of cable came aboard the schooner *Jennie Griffin*, and the task of sledding the huge cables out to the site fell to Sherman Smith and his teams of horses. Here we see the horses and their harriers pausing on Mesa Road for a rest. Facilities at the site included two large sending and service buildings, a residential cottage for the facility's manager, and a bachelor hotel for the workers. Wireless service began in 1914 between the United States and the Far East as well as providing radio contact with ships at sea. San Francisco mayor "Sunny Jim" Rolph came to Bolinas to exchange telegraphic greetings with the mayor of Honolulu.

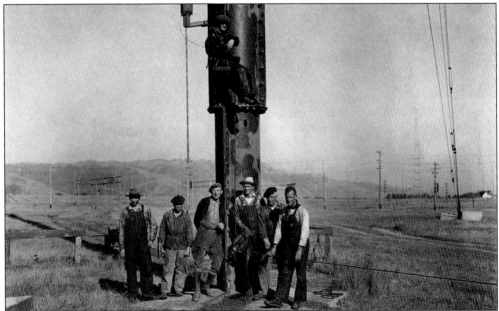

In 1919 Marconi Wireless sold their facilities in Bolinas and Marshall to the Radio Corporation of America. In 1971 the Coast Guard built a sending station on adjoining property. Rigging and maintaining the giant towers over the years fell to workers like local Jimmy Bourne and his crew. The salt air caused continual corrosion on the steel towers.

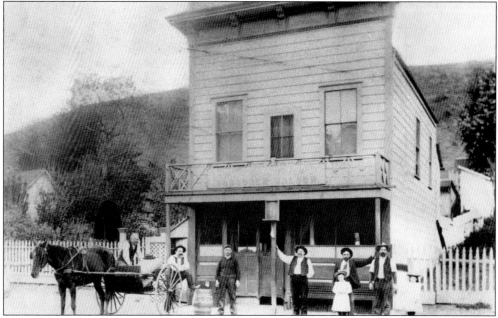

Real swinging doors provided access to the Schooner Saloon in this 1880s photograph. Today it is known as Smiley's. The claim is made that it is the oldest continuously operating saloon in California. This claim has been challenged by the Iron Door Saloon in Groveland, near Yosemite. While many saloons were converted to "soft drink parlors" during Prohibition from 1919 to 1934, Bolinas residents claim that "drinks were always available if you'd *speak easy*," and, of course, if the proprietor knew you. Since Point Reyes was the prime landing spot for rumrunners, the Bolinas Museum supports the locals' claim.

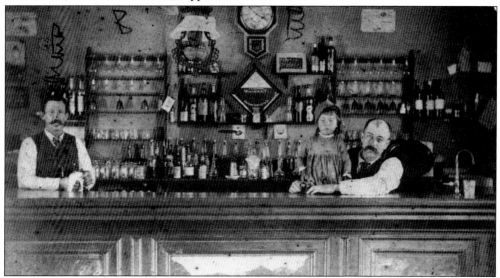

This image has been a part of Bolinas's heritage for many years. According to the notations on the reverse side, the three individuals inside the saloon are Mr. Eli, at left, and Jim Davis, with his arm around Ed Nott, who is about two years old in this photograph. Hank Nott owned a saloon in Dogtown in the 1890s and went to Alaska during the 1898 gold rush. He bought the Schooner Saloon in 1915 and called it "Ed's Nott Inn." Later Ed Nott himself ran it for 30 years.

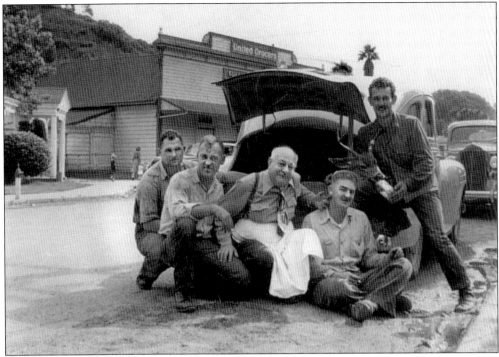

This photo, taken in front of the Schooner Saloon in the 1940s, captures a typical scene from that era when deer hunting was a favorite pastime. The hunters pose with their prize for a portrait, all descendants of early Bolinas families. From left to right they are Bud Ingermann, Jim Bourne, Ed Nott, the owner of the saloon, George Nidros and Herb Bourne. Since the arrival of the National Park Service, the deer hunting camps and the sound of rifle fire are a thing of the past.

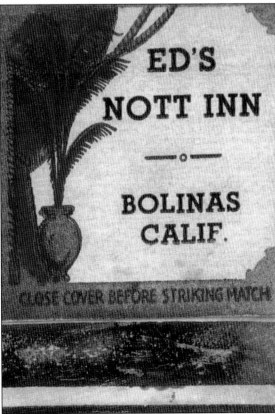

A matchbook from the bar and rooming house run by Ed Nott is shown here. It is hard to imagine a better name for a bar, but it is easy to picture the phone in the saloon ringing around 1930 and the barkeep answering, "Ed's not in!"

49

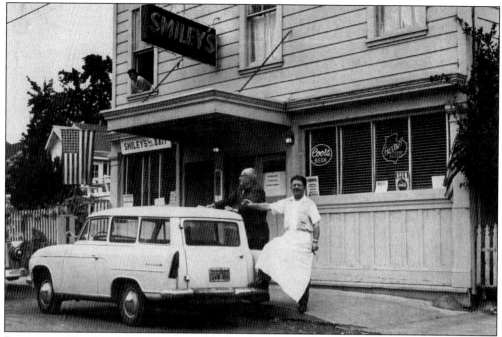

Remington Wood and "Smiley" Bianchini, with apron and cigar, pass the time of day in front of Smiley's bar about 1960. Under his legal name, Ismaele Bianchini, Smiley purchased the bar in 1956. He was an avid hunter and fisherman who had spent a lot of time around Bolinas in pursuit of game and he was always smiling, hence the nickname. He had previously run the Lincoln Bar and Bait Shop in San Anselmo and retired to do landscaping, but missed being around people. He converted half of the bar into a bait shop and held court for ten years. The next owner was Ray Gill, then Vernon Bradley, then Bob Glenn and finally its current owner, Don Deane.

Bolinas was a sleepy little town. In the early 1950s, local photographer Jim Foley snapped some candid photos of Bolinas in its doldrums. This early morning shot captures the town just waking up, and it still looks much the same today. Tarantino's restaurant, prior to its destruction by fire, can still be seen next to the Bolinas Market.

Five
By Land or By Sea

Access to Bolinas has always been an issue, and it still is. Before the convenience of the automobile and bridges, travel was an experience, an excursion taken in steps, often by foot to ferry to train to stagecoach, or by buggy to pier to schooner.

Getting to the town of Bolinas sometimes involved additional steps. Coming from the south might involve taking a train to a connection with a stagecoach that took you to Willow Camp where you had a choice: continue on to McKennan's Landing where a power launch would take you across the lagoon to Bolinas, or walk out to the end of the long sandspit where a call across to Bolinas would bring Chicken Charlie in a rowboat to take you across for a quarter.

There was also a trail from San Rafael through Fairfax to Liberty Ranch by foot or horse, and then up Bolinas Ridge to the Summit House, and then down to Bolinas. Eventually there was a

train to Point Reyes with stage connections to Bolinas via Olema. There were also direct stage connections to and from San Rafael. The stage driver, a vestige of the Old West with slouch hat, boots, leather gloves, pocket watch, and cigar clamped firmly between his teeth, was the hero of the hour for a good 50 years.

There was talk of a train coming from West Point on Mount Tamalpais down to the sandspit, and then to Bolinas. The track bed was indeed started but that was where that dream ended. The anticipation alone caused a building boom in Bolinas.

Reaching Bolinas by schooner from the city was always a possibility, even though the schooners were never licensed to carry passengers, but did anyway. The downside was that your fellow passengers might be frantic chickens or seasick hogs. There was one cautionary edict that most Bolinas folks always heeded: "Never take the schooner on hog day."

Eventually the roads improved and the horse-drawn buggies gave way to the horseless carriage and the schooner to the truck. The stagecoach gave way to the automobile, but it all took time. For a number of years after the automobile was marketed, few locals could afford them. The Bolinas stage still navigated the windy roads, but now it was a Stanley Steamer. There was a Greyhound bus that was kept in Bolinas in the 1940s and 50s. The driver lived at the Bolinas Villa and would take riders over the hill in the morning and bring them back in the evening. Then the Bridge District provided bus service on a regular daily basis until the 1980s. All of that is gone now, along with the Greyhound and all the other forms of public transportation.

Bolinas now depends upon the car, the truck, and the motorcycle. One can always bicycle or walk to Bolinas, but that is done primarily for sport or exercise. Whatever means one uses, one must also know how to get to Bolinas, as there are no road signs to point the way, but that's another story.

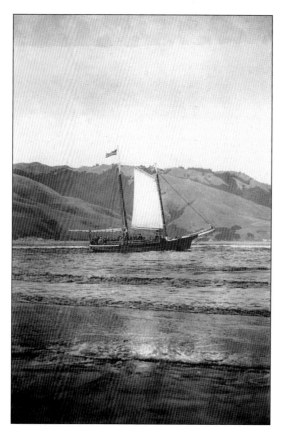

The *Jennie Griffin*, jauntily flying her colors, one sail up, and one down, powers her way toward the bar heading for market in San Francisco. This veteran schooner hauled all of the building materials and the huge cable reels for the construction of the Marconi Wireless Station in 1913.

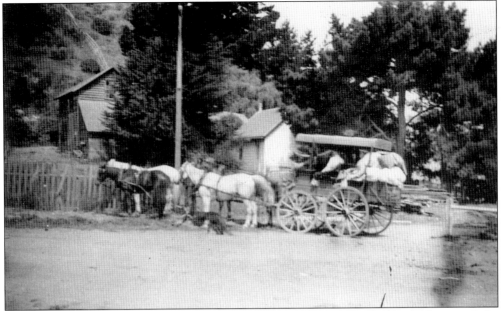

The stage prepares to make the return trip to San Rafael. If an individual wished to travel the route to Bolinas in 1898 they would take the North Pacific Coast Railway from the north or south to San Rafael where they could board the stage. A three-hour trip brought travelers to the hotel. The price was $2.50 round trip.

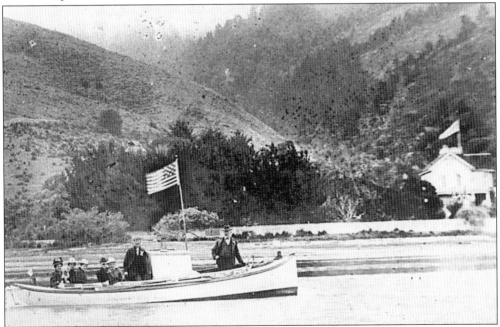

The *Alice F*, powered by a "Frisco Standard" single-cylinder gasoline engine, was owned and operated by Bill McKennan. The launch made regular round-trips across the lagoon from McKennan's Landing to Bolinas for many years. The site of McKennan's Landing, two miles north of Stinson Beach, is marked today by a few fragile pilings from the old wharf. Today visitors to the area stop at this spot to stare at the basking sea lions who, in turn, stare back.

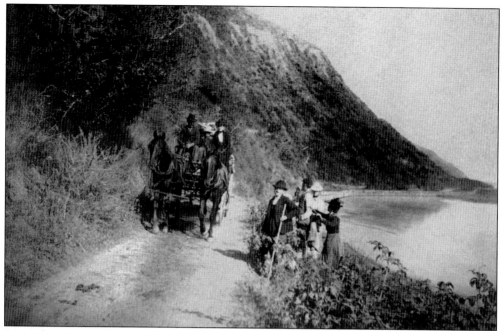

A wagon meets hikers along the road from Willow Camp to McKennan's landing in 1899. If a wagon or carriage was headed all the way to Bolinas by land, the driver would have to know the tides. Vehicles had to go onto the hard-packed tideflat to get around large rock formations.

The "road" around the Bolinas Lagoon was passable only at low tides. Finally in 1921 the county found enough dirt and manpower to create an all-season roadbed. This c. 1916 Gertrude Southworth photograph shows an auto pausing beside the affectionately named "Supervisors' Rock" at the north end of the lagoon.

The Bolinas stage, when it was operated by Langford & Crane, climbs the rise out of Gospel Flat in 1914. Motorized stages replaced the horse and wagon in 1911.

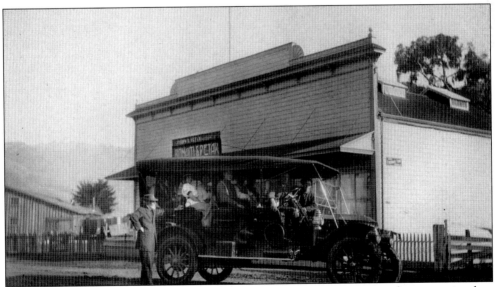

The Bolinas Stage about to head "over the hill" on its morning run, pauses for a portrait taken by Gertrude Southworth in 1915. Dr. Southworth stands beside the rig. This vehicle is one of the firm's silent Stanley Steamers.

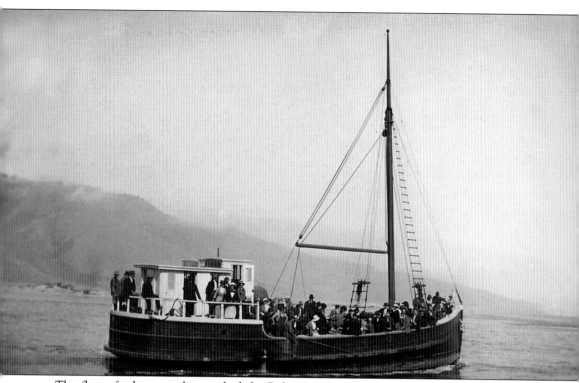

The fleet of schooners that worked the Bolinas-to-San Francisco run from the 1850s to the early 1900s dwindled as the county road system improved. However, there was still a need for the water connection to the city. Dr. R.C. Gibson, personal physician to Marin resident Congressman William Kent, had the power schooner *Owl* built in Oregon to fill that need. The *Owl* tied up for the first time at the landing at the ocean end of Wharf Road in 1911 amid great fanfare from Bolinas residents. Dr. Gibson paid the bill and made the trip from Oregon aboard the boat. That may have been enough water activity for him. He sold it shortly after to Louis Petar who operated it for twenty years. The boat, which drew six and one half feet, carried passengers and market products to the city and brought goods back to Bolinas. The boat operated on a regular schedule until 1933. The trip to the city was an adventure fondly remembered by many. Like the former schooner fleet, however, Bolinas residents who remember those trips are dwindling.

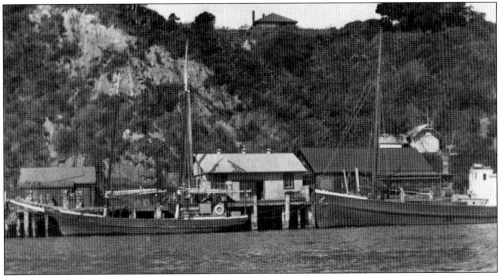

As the lagoon silted in and the channel became ever shallower, the wharf moved closer to the ocean. The wharf is seen here in its final incarnation at the end of Wharf Road. The two final workhorses of the schooner fleet, the *Jennie Griffin* and the *Owl*, await goods and passengers. The date is about 1915. Bolinas Highlands was subdivided in 1913 by Wallace Sayers and Sherman Smith. The roofline of one of the first houses peeks over the edge.

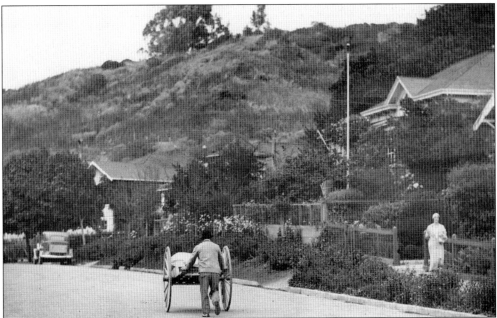

Holy Joe pushes his two-wheel cart down Brighton Avenue. Holy Joe was actually Leonard Josephson, former first mate on many Scandinavian sailing ships. He received his "Holy Joe" moniker from his long-standing work with the Presbyterian Church. He came to Bolinas before the 1906 earthquake and created a career for himself by meeting the incoming schooners at the pier, loading visitors' bags onto his cart, and transporting the goods to the owners' home or lodgings. Holy Joe was also the caretaker for many of the summer folks' homes. If he knew they were coming, there would be a fire going for them in the fireplace when they arrived.

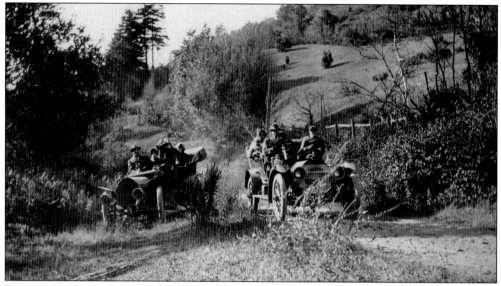

Two autocars stop for a portrait along the Olema-Bolinas road around 1914, probably after terrifying a few horses on the way from San Rafael. Dr. Southworth rides shotgun in his vehicle on the right. He owned one of the first automobiles in Bolinas but never drove it.

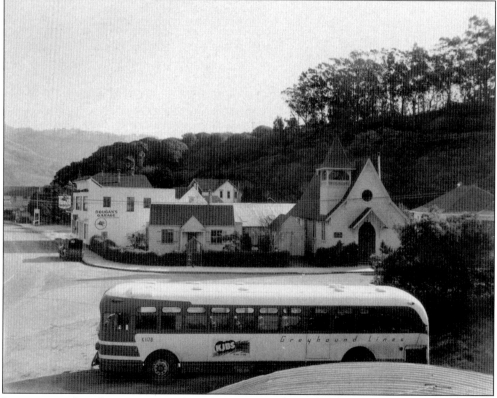

It is just another sleepy morning in Bolinas in the 1950s. The driver of the Greyhound bus roomed at Bolinas Villa. He would drive the bus over the hill in the morning and back out in the evening.

Six

NATURE RULES

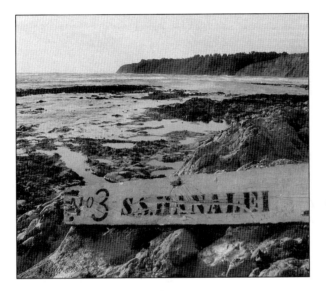

Locals became used to the whims of nature and learned early on that one had to adjust to this isolated and sometimes environmentally hostile location. The first recorded earthquake, an omen of what was to come, hit Bolinas in 1866. When the big one came in 1906 it was not unexpected, but its intensity stunned residents. Bolinas suffered more damage than any other town in Marin.

Townsfolk witnessed many shipwrecks on Duxbury Reef as boats groping for the Gate in the fog, or mistaking a bonfire or light on shore as the entrance to San Francisco Bay, plowed hard on to the reef. Massive ships were pounded to splinters. For years residents of Bolinas had salvaged cargoes from which they built their homes, and rescued stranded passengers and crews, and some locals had died in the process. A Lifesaving Station was established here with surf

boats and trained crews to better serve the stranded mariner. Eventually it became the Coast Guard Station until radar was invented during World War II.

Residents watched helplessly as lightning-sparked fires walked slowly up or down Bolinas Ridge. They formed a fire department early on for the protection of their property but didn't bother interfering with nature's plan for the landscape.

In 1956 the town was inundated by days of rain that drenched the hills beyond their saturation point, flooded the roads and sent a series of huge landslides crashing into the downtown. Five homes were destroyed or heavily damaged. Emergency crews could not get through, so locals formed their own emergency crew.

While the earthquake of 1906 had its epicenter in Olema, and most public attention was riveted to the devastation in San Francisco, the little town of Bolinas suffered more damage than any other town in Marin. Two-thirds of the structures in town were damaged and many shifted off their foundations. All the chimneys tumbled. The lagoon bottom rose in some areas and sank in others. The stage was trapped inside the Sayers stable so it could not make its regular runs for several days. The flagstaff of the Flag Staff Hotel lay in the road while the hotel and its companion structures all along Wharf Road were tipped into the lagoon. Huge fissures opened in the roadbed in Gospel Flat. Water tanks fell. Terrified cattle took off for the hills and dairy cows stopped giving milk. Although no residents died due to the quake, many nerves were shattered by the experience, and the town was a long time rebuilding.

Pounding waves, receding cliff faces, bulkheads washed to sea and homes sliding into the ocean became a part of life on the edge. While the Lifesaving Station was active, its lookout on Little Mesa was moved three times from the receding cliff edge. Since then it has been moved another three times.

Although the 1971 oil spill just outside the Golden Gate was man-made rather than nature's handiwork, the oily waves that nature carried to Bolinas's shore were more than locals could cope with. A call went out to radio-listeners in San Francisco. Many responded and worked tirelessly to clean the beaches and save the oil-soaked birds. Some workers stayed and reshaped the town into what it is today.

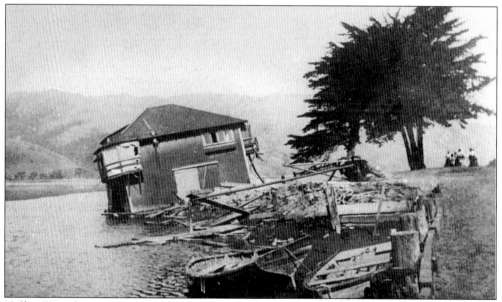

Nellie Waterhouse's studio is shown here shortly after it tumbled into the lagoon in the 1906 earthquake. Her studio was the meeting place for Bolinas social events including holiday parties.

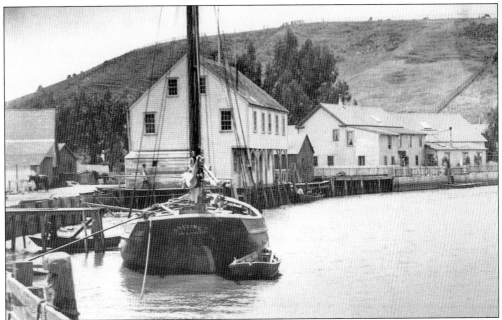

Before the fall: this idyllic photograph of the Bolinas hotels was taken from the Waterhouse warehouse and studio shortly before the quake. Every structure in the photograph was destroyed or damaged in the violent trembler. This area was known as "Jugville" due to the number of drinking establishments, including the Schooner Saloon and Redman's Bar.

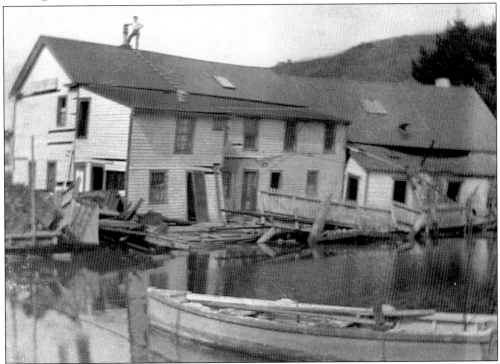

After the fall—this photograph was taken the morning of the quake, while aftershocks were still rolling through the town. The figure stands atop the Flag Staff Inn. Demolition would soon begin.

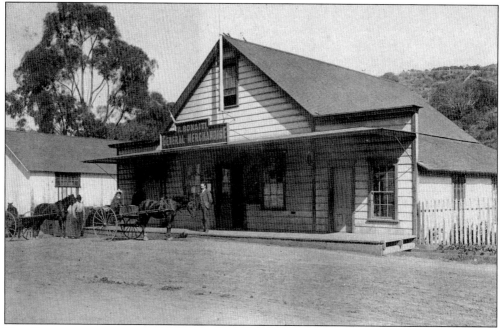

The Bonaiti grocery store, with Attilio Bonaiti himself on the porch, was photographed by George Harlan of Sausalito shortly before the quake hit.

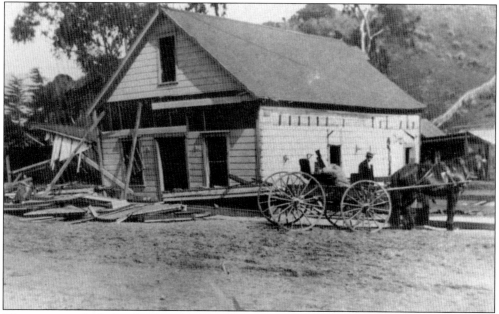

The grocery took the hardest hit of any building in Bolinas, as can be seen in this image. It was slowly taken down and rebuilt as the Bolinas Grocery we know today.

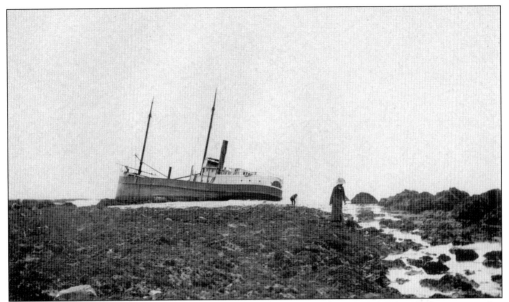

The *R.D. Inman* is seen here in 1909, hard aground on Duxbury Reef. The ship ran onto the reef stern first in dense fog. Efforts to get it off were futile. It swung sideways and settled in for a long decline. Salvagers were hired to save what they could. The steam schooner was going to break up slowly, thanks to its position on the reef, so an actual camp was set up on shore where the salvagers lived.

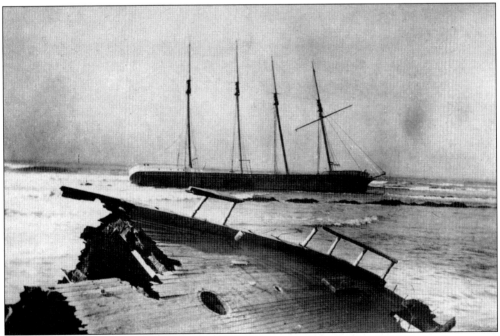

The four-masted *Polaris* has also run hard aground on Duxbury Reef in 1914. In the foreground is the stern of the *R.D. Inman* at Bolinas Point, just below the radio towers at R.C.A. No lives were lost in either wreck.

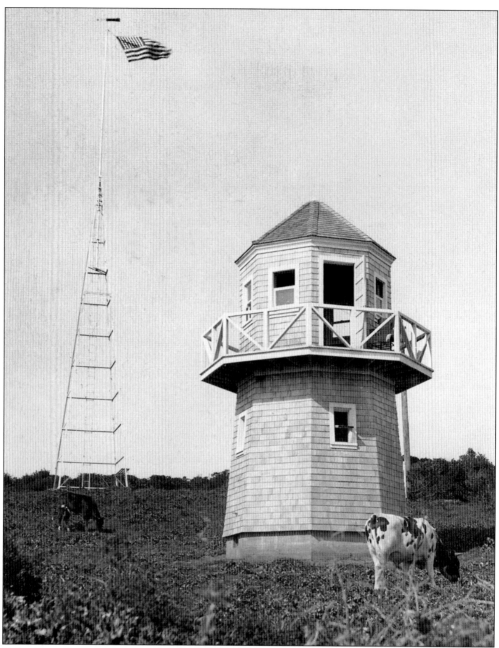

Bolinas watched the wrecks pile up on their windward side—the *Lewis* in 1853, *Western Shore*, *H.C. Almy*, *Esperanza*, and *Claus Spreckles*. They just kept coming—the *Nettie Low* in 1900 followed by the *Inman* in 1909, the *Polaris* in 1914 and the *Hanalei* shortly after. The *Hanalei* wreck resulted in 23 deaths. The good citizens of Bolinas petitioned the government for a manned lifesaving station. The bill passed through the legislative corridors in record time. Seven months after the *Hanalei* went down, the station was under construction. It was clear that lifesaving crews would need a good view of the ocean, so a lookout station was built near the edge of Little Mesa. Because it resembles a lighthouse it has generally been referred to by locals as well as visitors as "the lighthouse." It was manned 24 hours a day by station officers.

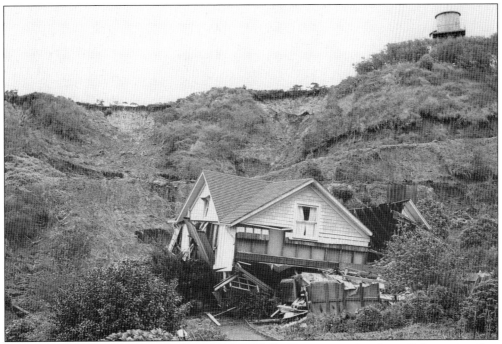

In January 1956, "mud poured off the Bolinas hills like rivers of molasses," destroying four homes. The Bourne home slid from its foundation, went through the front yard, taking along a hedge and gate, and finished its 60-foot slide in the middle of Wharf Road. Stunned residents responded to the crisis and pitched in with the clean-up and repairs.

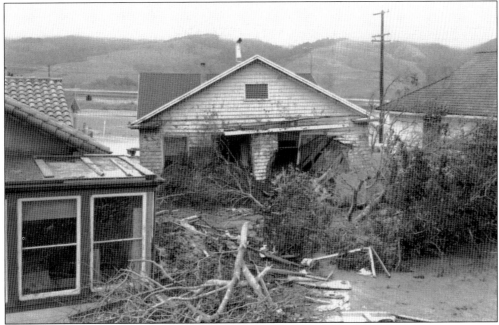

The rear of the Bourne home after it was shoved out onto Wharf Road. Mrs. Geneva Bourne had just prepared dinner for four when the landslide struck. Everyone was thrown against a wall as the house slid, but all escaped injury.

Ed Aitken's house was pushed off its foundation by the mudslide. In this photo it appears to have slid a large distance, but in reality it only moved about three feet. To resolve the problem in the simplest way, Ed hired Don Pepper to jack the house up and put a new foundation under it in its new location.

Mud was everywhere. Traffic stalled at the northern end of Brighton Avenue because of the slide. Jimmy Dougan and his assistants at Dougan's Garage took on the seemingly endless chore of pushing cars through the river of muck. Considering the awful force of nature that they had just witnessed, all involved were amazed that no one in Bolinas was killed or injured in the landslides. These mudslide images were all recorded by Jim Foley.

Seven

MAKING DO

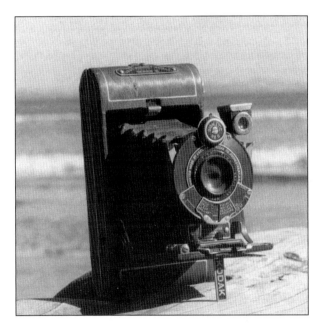

We know of no carnival or circus that ever visited Bolinas. No elephants or lions here—only elephant seals and sea lions that barked in the night. In 1915, during the Panama-Pacific Exposition in San Francisco, a contingent of Plains Indian chiefs came to Bolinas and had their pictures taken on the beach and then left. Bolinas was not generally a magnet for entertainers, so residents learned early on that if they wanted to be entertained they'd pretty much have to do it themselves.

Almer Newhall thought the town needed to celebrate Independence Day so he organized a celebration on July 4th, 1895, and got everyone in town to march. The photographs show that so many had been drafted to march that there were no spectators. Over the years the parade became a relatively consistent tradition. The giant bonfire and fireworks show on the beach

became a regular event until the blackouts of World War II put a stop to the festivities.

Charlie Page liked moving pictures in the early years of the last century but there was no movie theater in Bolinas. So he rode on the *Owl* to San Francisco every summer weekend, rented 16-millimeter, two-reel silent films, took the *Owl* back to Bolinas, showed the films in the first community center, where he charged 10¢ at the door and the next day returned the films to San Francisco. In the 1920s George Scott Miller made his own movies in Bolinas and showed the subtitled films to anyone who wanted to watch them.

Several annual events occupied the Bolinas community calendar. They celebrated May Day near the Tully house on Brighton Avenue, where school children gathered around a maypole, doing intertwining ribbon dances to a hand-cranked Victrola. Clean-up Day on Memorial Day weekend found the whole town turning out with rakes, shovels, and pickup trucks to cut weeds, clean ditches, and bring a sense of decorum to the town before the workers shared a huge potluck dinner set up on the tennis courts. The Rummage Sale in late summer was for years a major closet-cleaning event that got a surprising amount of ink in the San Francisco papers, thanks to the city families who summered in Bolinas every year. It also gave residents a chance to buy back that thermos they donated the year before.

Locals formed clubs around mutual interests, be it sewing, reading books, or killing deer. Some joined just to get out of the house. Nellie Waterhouse formed a women's social club in 1908 that met regularly at her Wharf Road studio, and a community center was built in the 1920s. Church and social events consumed whatever little time residents had left over.

Marji Miller deGreeve recalls that in the mid-1940s "Pheff" Pheffecorn and his wife Rose, the Bolinas kindergarten teacher, showed two-reel movies in their home every Saturday night, serving popcorn between reels. When Mildred and Alf Haraldsen on Brighton Avenue bought the first TV in Bolinas, they opened their living room Monday through Friday afternoons for all local children to watch the *Howdy Doody Show*. It was BYOP—bring your own popcorn.

A new community center was built in the 1950s that serves the town's needs today and much of the entertainment is still local. The July 4th parade is still *the* event of the year. Now it is more a celebration of the right of free speech and the right to dress accordingly than a celebration of patriotism per se.

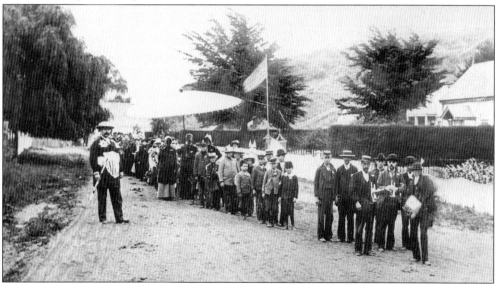

Almer Newhall, in patriotic attire, prepares to lead the first recorded Bolinas Independence Day parade on July 4, 1895. No spectators can be found in the three existing photographs of the event that day. It can be assumed that the musicians (the Nott boys) and the marchers paraded to their own applause.

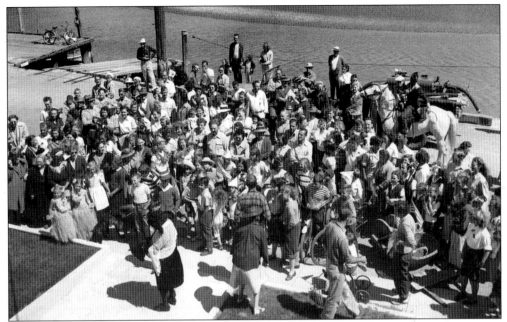

Decorated bikes, the fire truck, a horse, dogs, kids in costume, matriarchs and patriarchs turn out for the singing of the National Anthem in front of the Coast Guard station on Wharf Road prior to a July 4th parade in the 1940s. Judging from population figures of the time, this crowd could represent the majority of Bolinas residents.

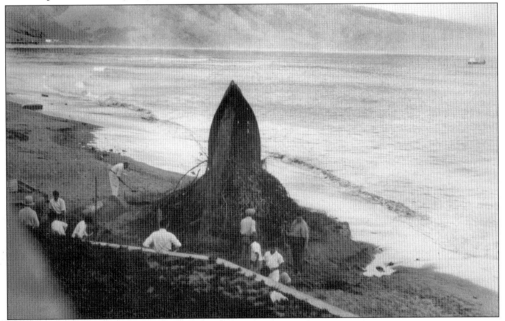

Preparations for the Independence Day bonfire on Bolinas Beach are underway in this photograph. Almer Newhall, longtime supporter of July 4th activities, organized the bonfire and the evening fireworks display on the beach annually. The beach was always a popular gathering spot. For years, Marin Waterhouse Pepper's teahouse, La Casita de la Playa, was a popular gathering place. Visitors could rent bathing suits and there were plenty of changing rooms.

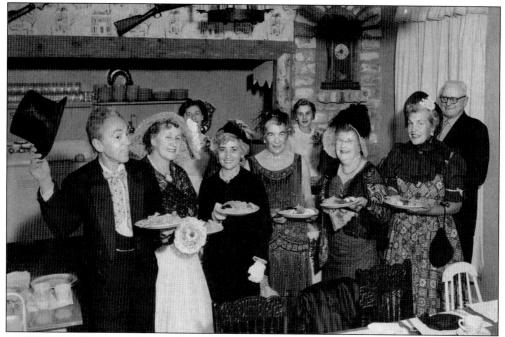

In 1956, Myrt Pepper and Doris (Pepper) King reopened the Gibson House as a restaurant and the opening night party was quite a scene with many Bolinas folks turning out in historic costumes. Those pictured here include Erwin and Ethel Manheim, Elsa Ringens, Dr. Wilcott, and Myrt and Doris.

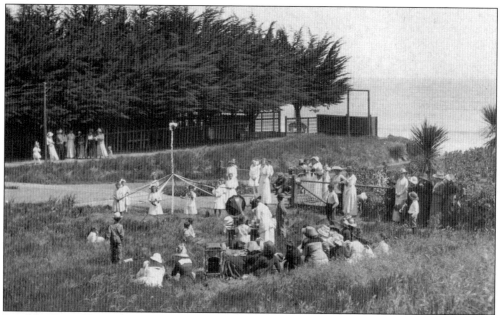

It is May Day 1921 and a group of schoolchildren pause during their May pole dance while the teacher changes the record on the hand-cranked Gramophone. The location is the foot of Brighton Avenue, which looks much the same today.

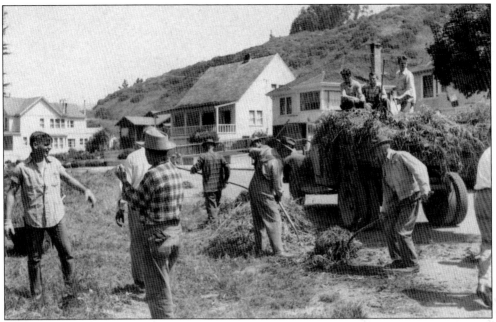

The county did little to maintain the roadways in and around unincorporated Bolinas, so the residents would do it with an annual "Clean-up Day" during the Memorial Day weekend. Activities included clearing weeds and trash along all the town roads, testing the fire equipment, and eventually, a big potluck on the tennis courts.

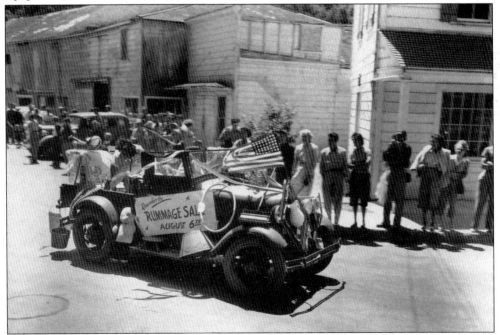

The annual rummage sale is promoted in this late 1940s parade float. The rummage sale and other Bolinas social events of the 30s and 40s often received full-page coverage in San Francisco newspapers because so many of the Bolinas "summer people" were also part of San Francisco's social scene. This photo was taken by Paul Tracey in 1949.

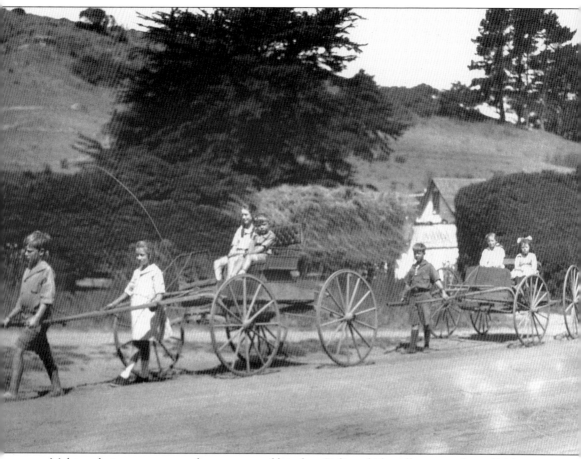

Making their own summer fun, a group of barefoot Bolinas kids pull wagons down Brighton Avenue toward the beach. John Page and Gwen Elliot pull the lead cart carrying Muriel Ellio and Tom Page, while Stanley Page pulls Anne and Lydia Cappi behind them. One of the Briones Dairy buildings peeks out through the cypress hedge that surrounded the Waterhouse property. Although Bolinas was the commercial hub of Marin County and an active year-round community for 150 years, the summer months remain the best part of the Bolinas experience.

Part II
STINSON BEACH
BETWEEN THE OCEAN
AND THE MOUNTAIN

Stinson Beach is located at the base of Mount Tamalpais in Marin County, California. Depending on the weather and traffic, it is about a 30-minute drive south to the Golden Gate Bridge and San Francisco.

In the course of the last 100 years, an isolated, sparsely populated, rural area has evolved into one of the richest towns in America. Apart from the sheer beauty of the area, several events account for this. Before there were roads, Willow Camp, as it was first known, could only be reached by foot, horseback, or boat. In the mid 1800s, Capt. Alfred Easkoot, a retired sea captain, bought land and rented out tents to visitors. Captain Easkoot then built his home, the first in the area, in 1883.

In this era most visitors took a ferry to Sausalito, then the Mill Valley and Mount Tamalpais

Scenic Railroad to West Point, the terminus of the railroad, on the side of the mountain. Then came the long hike to the beach. One really had to want to come here and many did. In 1870, a narrow dirt road was completed from Sausalito to Willow Camp. But it was a hazardous journey and often closed for repairs, as it is sometimes today. There were plans for a railroad from West Point to Willow Camp, but the 1906 earthquake put an end to that dream.

As people fled San Francisco, a town began to develop when refugees settled on the hillside while building commercial establishments in the center of town on Highway 1. By 1916, a post office was established and the town was renamed after its largest land owner, the Stinson family. Growth was slow but there were always facilities to accommodate the many people who visited the beach, especially during inland heat waves. In 1937, the Golden Gate Bridge was opened and Stinson Beach became accessible to those who just wanted to spend a day on the beach.

During World War II, the town ceased to be a beach resort as the military patrolled with sentry dogs day and night. In addition, large bunkers were built on the cliffs above town. Since Stinson had the nearest available housing, many of the workers at the Sausalito boat yards moved into what had been summer cottages. There were four busses a day to accommodate the military shift changes.

After the war the highlands above town were developed and shortly thereafter the Seadrift gated subdivision was established. The Bolinas Lagoon was dredged and Dipsea Road was created for additional lots. In 1972, the Golden Gate National Recreation Area took over the State beach along with all of the land surrounding Stinson Beach. Essentially, this put an end to any new development. Slowly home prices began to rise and by the 1990s, even humble properties were selling for over a million dollars. Sticker shock is common when visitors look at this listing at the realtors' offices.

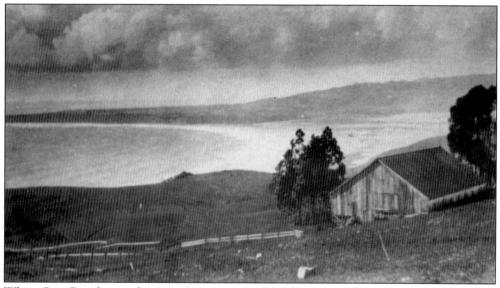

White Gate Ranch, seen here in 1890, sat upon the hills commanding a view of a three-and-one-half-mile crescent-shaped beach, later to be named Stinson Beach.

One

EARLY DAYS AS A
TENT CITY

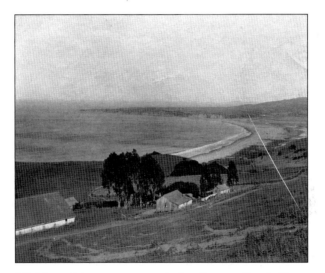

On the occasion of California's sesquicentennial, the Stinson Beach Historical Society joined others to erect a tombstone at Bolinas Cemetery, marking the grave of Stinson Beach's most memorable pioneer, Capt. Alfred Derby Easkoot of Manchester, Mass.

Capt. Easkoot set out for San Francisco to take charge of the barque Asa Packer. In 1852, a year after he moved to Bolinas, he began farming and raising cattle on Isaac Morgan's Belvedere Ranch on the northeast side of Bolinas Lagoon. In 1853 he was elected Marin County's first surveyor and was instrumental in the building of the first county road from Sausalito to Bolinas. He bought much of the beachfront along Bolinas Bay from Morgan (an area later referred to as Easkoot's Beach) and more than 100 acres of tidelands. He married Amelia L. Dumas of Philadelphia on July 4, 1861.

In 1871, Easkoot's friend Capt. Joe Hoxie and his wife came to Sausalito and lived for seven weeks on Easkoot's beach. Others followed and by 1879, there were 20 family tents on the beach, plus canvas dressing rooms for men and women. The captain collected fees for renting the tent platforms and restrooms, took fishing parties to sea in his boat Margaret, lit bonfires on the beach at night, and organized games and song fests. (From the notes of Norman C. Staub Sr.)

Capt. Alfred Easkoot first settled in Willow Camp in 1871 and by 1879 used his beach property to set up tents for vacation campers.

Captain Easkoot's two-story, New England-style house, built in 1883, was the first home in Willow Camp. It still stands today, although it was severely damaged by fire in the early 1970s. Note Easkoot's barn and cattle grazing in the foreground.

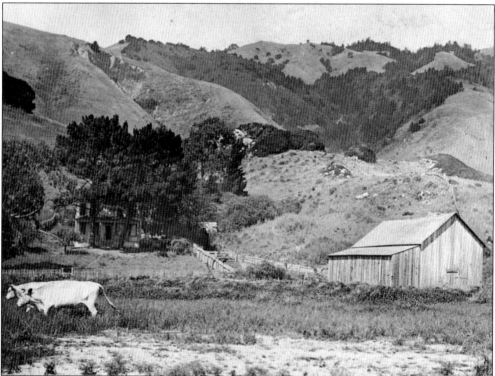

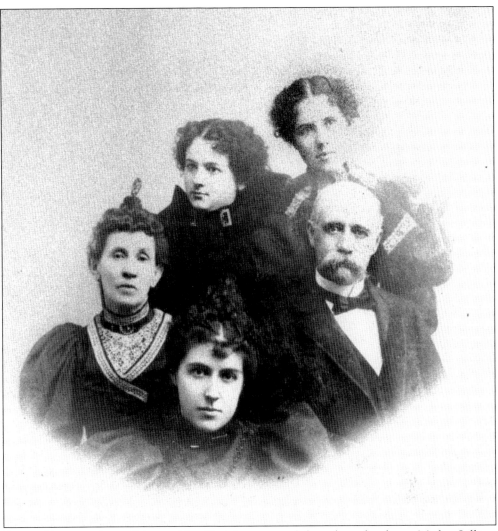

Pictured here are Amos Stinson, his wife, Margaret, and their three daughters, Madge, Lillian, and Eve, in the 1880s. The Stinson family played an important role in the development of Willow Camp, later renamed Stinson Beach after their family. Amos was the son of Nathan Stinson, who along with James W. Upton bought out Captain Morgan's 1,720 acres along the east side of the Bolinas Lagoon, including the sandspit. After the death of Upton, Nathan Stinson married his widow, Rose, and became the stepfather of Archie and Ida Upton. Rose and Nathan set up a resort that competed with Easkoot's Beach called Willow Camp, which soon became the name of the area before it became Stinson Beach.

In the beginning people came to Willow Camp (Stinson Beach) by schooners via Bolinas, or on horse back from San Rafael via Olema and Dog Town. Many more hiked here on Lone Tree Trail, later called the Dipsea Trail, from Mill Valley.

Hikers make progress down the trail behind the Stinson Ranch in 1901. (Courtesy of the Sausalito Historical Society.)

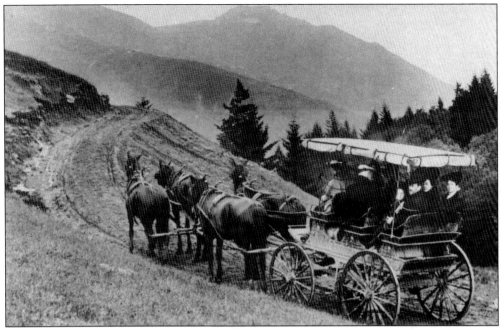

This stagecoach ran from West Point on Mount Tamalpais above Mill Valley to Willow Camp and McKennan's Dock, which would take passengers by launch to Bolinas. The round-trip fare was $1.75 when this photo was taken *c.* 1906.

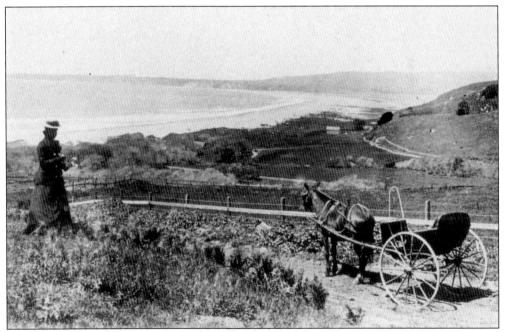

A lady takes in the view in 1900 near White Gate Ranch abov the south end of town. (Courtesy of the Sausalito Historical Society.)

Shown here is the bridge over Easkoot Creek, coming into town, as it appeared in 1904. This road became California Highway 1, also known locally as Shoreline Highway. (Photo by Edgar Cohen.)

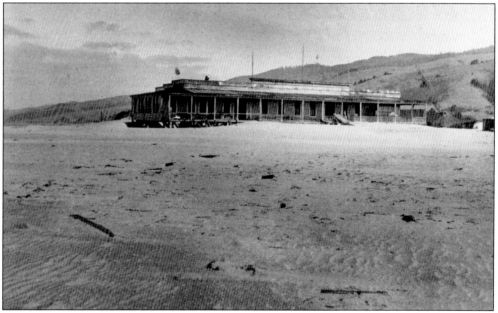

The deserted Dipsea Inn was located on the sandspit, which is now the gated Seadrift Subdivision. It was one of many failed attempts to build a permanent hotel in Stinson Beach. Although the inn was torn down in 1918, the building materials were used to construct the Dipsea Lodge, also located on the beach but much nearer to the center of town. The failure of the inn was related to the abandoned plans to run a railroad to it from Mill Valley.

Fourth of July Program

Willow Camp 1887

MORNING

1. Salute of 38 guns at sunrise.
2. Procession.
3. "America" — By the Camp.
4. Reading of the Declaration and Oration — S. F. Barstow.
5. Song "Columbia, the Gem of the Ocean" — Mrs. Clark and the Camp.
6. Drill by the Easkoot Guards.
7. Lunch.
8. Preparing for the Campfire.

EVENING

9. "Star Spangled Banner" — By the Camp.
10. Recitation, "The Little Hero" — David Kidd.
11. Song and Chorus, "She Stood Alone on the Shore" — Mr. J. Brown, Misses Mary, Edith, Ada and Alice Brown, Misses Lulu and Susie Bishop.
12. Recitation — J. Jukes.
13. Song and Chorus, "Naughty Jemima" — Mrs. Hoxie.
14. Tableau, "The Three Graces" — Misses McDonald, Calvin, and Williams.
15. Duet.
16. Tableau — The Goddess of Liberty.
17. Recitation — A. H. Downing.
18. Harmonica Solo — A. J. Dunbar.
19. Tableau — The Council of War.
20. Recitation, "Barbara Freitchie" — Ella Calvin.
21. Song — Miss Hoxie.
22. Tableau — Crowning of George Washington.
23. Fireworks on the Beach.
24. Rallying 'round the Campfire.
25. Chocolate Party in Pavilion Grounds.
26. Dancing in the Pavilion.

Nathan and Rose Stinson set up a resort to compete with Easkoot's camp in about 1883. Called "Willow Camp," it had its own newspaper, *Willow Whistle*, and a dance floor. This issue of *Willow Whistle* advertises the events of July 4, 1887.

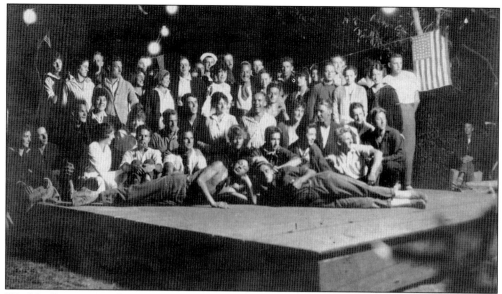

Weekly dances at Willow Camp were very popular. This photo was taken on the Fourth of July in 1916.

This 1916 photograph shows the Littleton family compound at Willow Camp decorated for the Fourth of July.

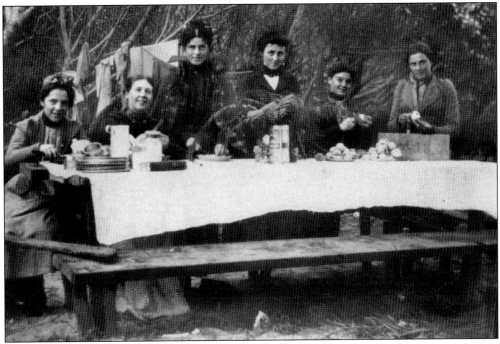

These snugly-outfitted young ladies appear to be happy campers while preparing victuals on a local campground in 1901.

The children playing on the lagoon in 1910 are, from left to right, Dick Dunn, Rob Dunn, Betty Bibbins, Lorna Doughty, and Ardah Bibbins. Note the sandspit on the background.

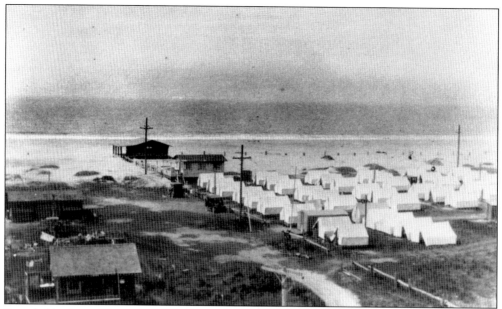

Founded by James Upton in 1905, Camp Upton was a very popular destination with summer vacationers. This view shows suplus army tents and Upton's log cabin in the upper left. When developed, this area became known as the Calles.

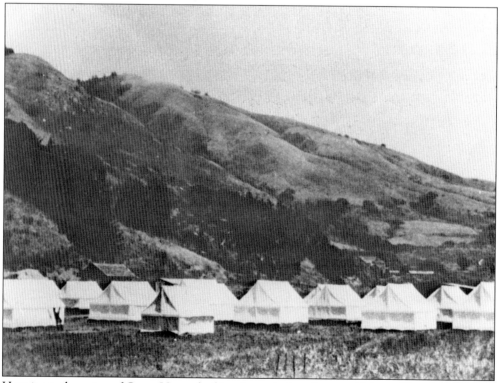

Here is another view of Camp Upton looking from the beach toward Mount Tamalpais.

Two
BIRTH OF THE TOWN

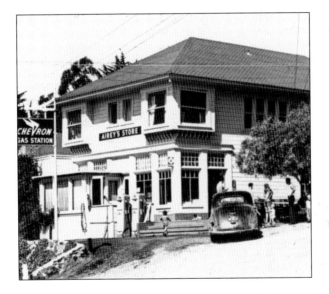

The first fire department, grocery store, ambulance, church services, telephone exchange, town meetings, etc., all took place in the hotel which Harry and Elizabeth Airey built on the corner of the main road and Calle del Mar in the heart of the village. And although the town's post office didn't originate there, it, too, for a time was located in the back of the building.

After Jack and Sarah Airey built their large three-story hotel on the main street in 1913, it also became a community gathering place where meetings and church services were held until the hotel closed in 1945.

Brothers Harry and Jack Airey and their families had lost their homes and foundry business in the San Francisco earthquake of 1906. They, after a brief stay in Sausalito, decided to move to Willow Camp full-time. They were regular weekend visitors there and Jack had already purchased a lot on the main road and had built a small storage shed on it.

Their coming to the community at this time, and their contribution to it, were the best things that happened to the town. They were the true founders of what later come to be called Stinson Beach.

—From the book *Memories of Willow Camp* by Joan Reutinger

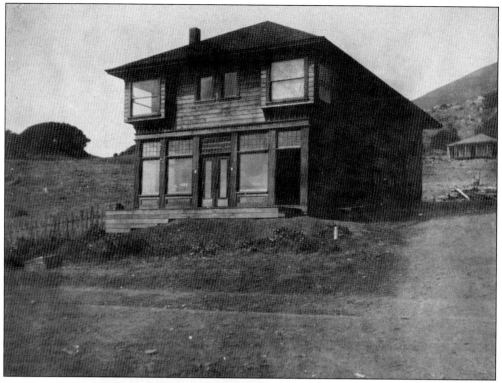

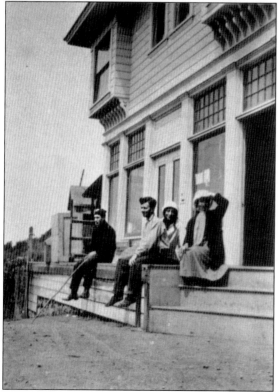

Located in the center of town, Hotel Airey was built in 1906 as a rooming house. In the 1920s, the hotel became known as Airey's Store because of the demand for groceries by the growing population of locals and campers. The building stands today as the town grocery store, although there have been many structural modifications. While six successive concessioners have run the store over the years, the building is still owned by the Airey family.

People hang out on the porch of the Hotel Airey, c. 1907. This corner of town continues to be a favorite gathering spot for locals and visitors alike.

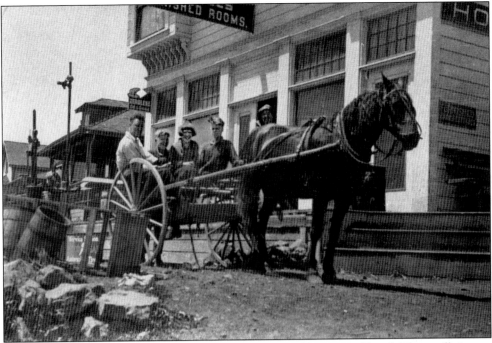

Frank Airey is seen here with a horse and buggy in front of his parents' hotel. The small sign on the right of the building reads, "Furnished Rooms and Cottages."

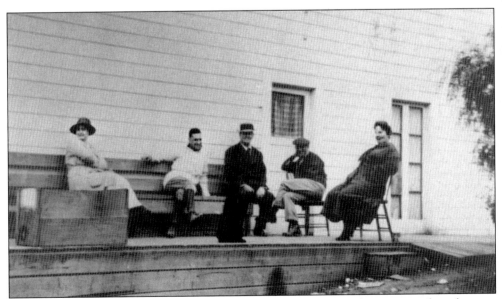

Benches were added to the porch of Airey's Store and were a great place to sit and catch up on the latest news.

Looking south in this view, the unpaved road leading to Willow Camp was called the "outside road." Though long paved and known as California State Highway 1, it is still a work in progress, as it needs constant attention and repair after winter storms.

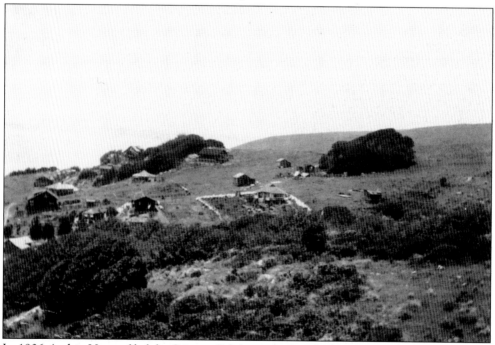

In 1906 Archie Upton filed for Stinson Subdivision #1 with the County of Marin. By 1910, what is now known as "Old Town" had its beginning as the first subdivision on "the hill," as Mount Tamalpais is known locally. "Going over the hill" means a trip to eastern Marin County or even San Francisco.

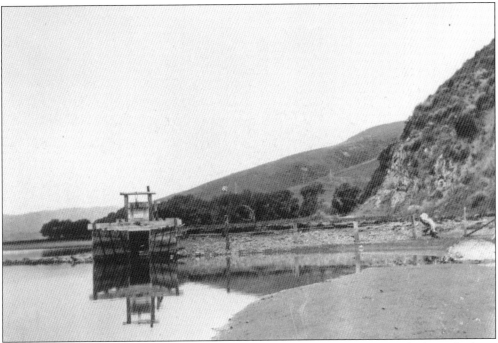

This photo shows the tidal gate on the causeway that led to the Dipsea Inn, which was built on the sands pit.

This early view shows the dirt road going south towards Willow Camp along the edge of Bolinas Lagoon.

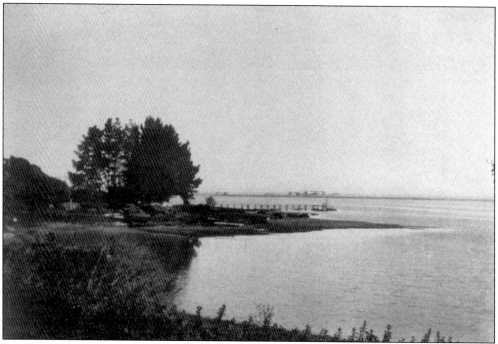

McKennan's Dock juts out into the east side of the Bolinas Lagoon. The Dipsea Inn can be seen on the distant sandspit.

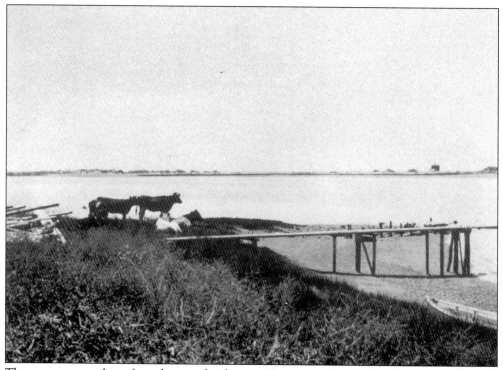

There were a number of ranches north of town. Here, some cows enjoy the view of Bolinas Lagoon, c. 1910.

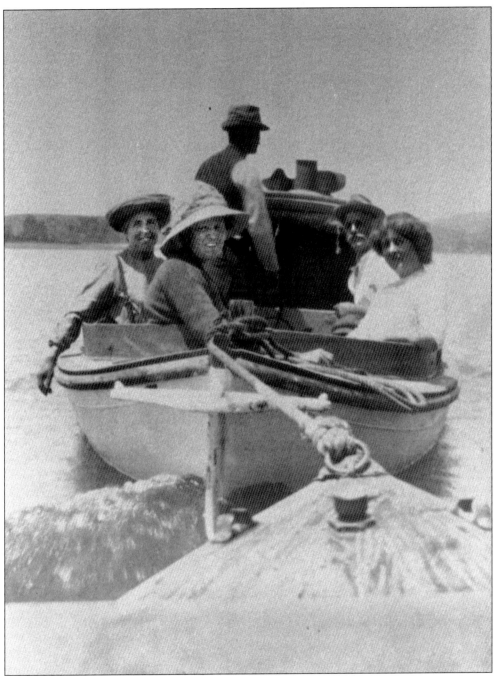

The *Alice F* was owned by Bill McKennan, who is seen here at the wheel with passengers bound for Bolinas, *c.* 1913. Pictured from left to right are Edith Dunn, unidentified, Bill McKennan, Joseph Dunn, and Eva Dunn.

This photo captured haying operations at White Gate Ranch in 1912. The ranch continued to function above the town until the late 1970s, at which time the buildings were torn down when the land became part of the Golden Gate National Recreation Area.

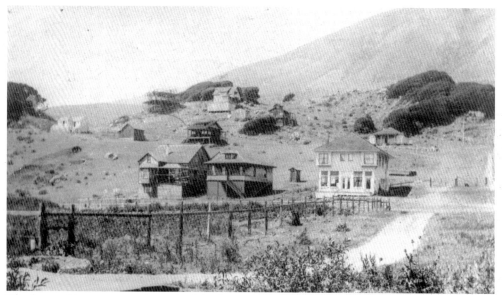

The large white structure shown in this photo is the Hotel Airey. To its left is the home of Newman and Eve Stinson Fitzhenry, and next to it Lillian Stinson Hensill's home. The large house under construction on the top of the hill was owned by Archie Upton.

Jack and Sarah Airey take a moment's pause from their commercial endeavors to pose on their front porch.

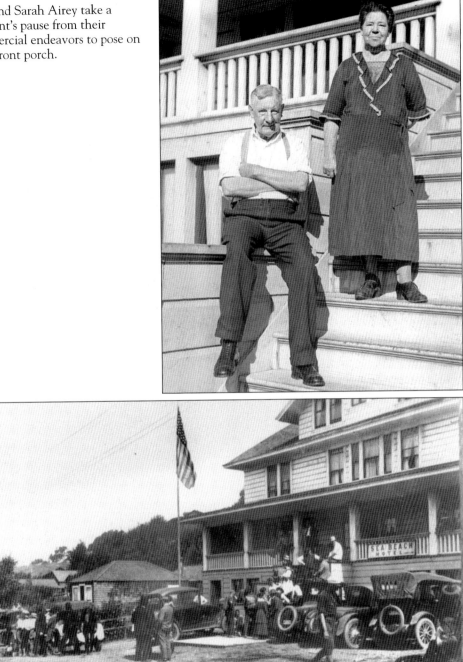

Following the great earthquake of 1906, brothers Jack and Henry (Harry) Airey moved to Willow Camp and helped each other build separate hotels. Jack owned the Sea Beach Hotel and Henry owned Hotel Airey, a half-block away. This photograph has captured a busy summer day in the 1920s at the Sea Beach Hotel owned by Jack and Sara Airey. Sadly, the Hotel Airey burned down in 1971. Sadly, the Sea Beach Hotel, which had been renamed the Grand Hotel, burned down in 1971.

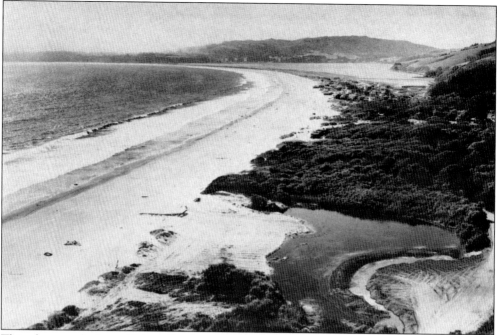

This photograph shows Poison Pond to the right of the beach. Officially christened Willow Camp Lake, the nickname was added by local parents who tried, with varying degrees of success, to keep their children from playing there. Thought at one time to be filled with huge snapping turtles, pond was drained by the State of California when it took over this part of the beach.

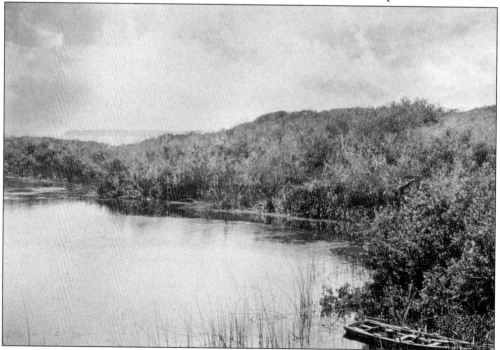

This tranquil photo was taken by Edgar Cohen at Willow Camp Lake in 1900. Note the boat at bottom right.

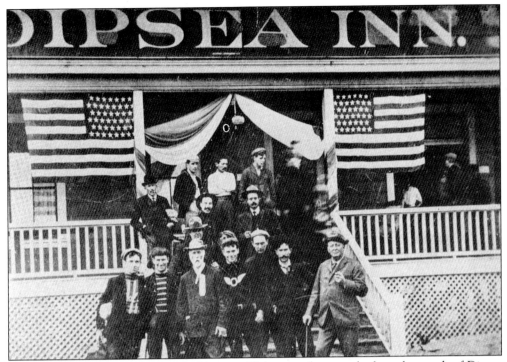

Dipsea racers from San Francisco's Olympic Club were photographed on the porch of Dipsea Inn in 1905. By 1918 the first women's race was held. Called the Dipsea Trail Hike for Girls, it was sponsored by the S.F. Bulletin. It wasn't until the 1960s that women ran with the men.

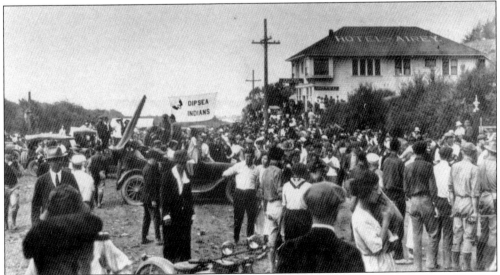

A crowd mills around the finish line of the Dipsea Race in front of the Hotel Airey. The first race was run in 1905 across Mount Tamalpais from Mill Valley. It is still run to this day with very few changes to the original course.

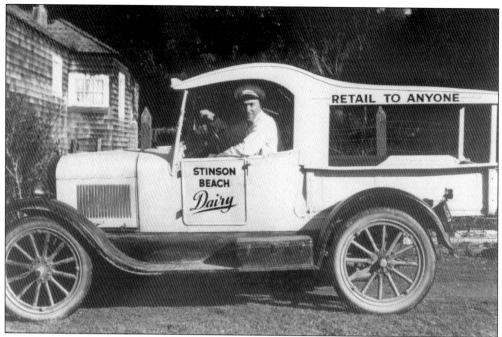

Local milkman Joe Avila sits at the wheel of his delivery truck. The Avila Ranch House is one of the oldest homes in Stinson Beach. One can't help but wonder about the significance of "RETAIL TO ANYONE."

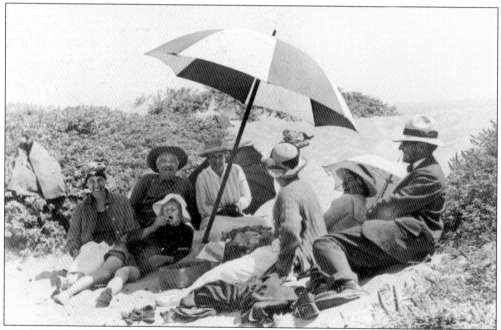

People enjoyed a picnic on the beach even on a foggy day.

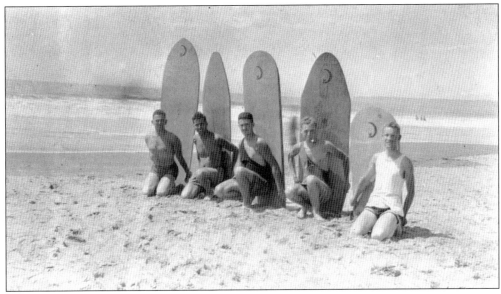

This group of surfers called themselves the "Moon Club." Unfortunately the origin of the club name has been lost to history. Could it have something to do with outhouse doors?

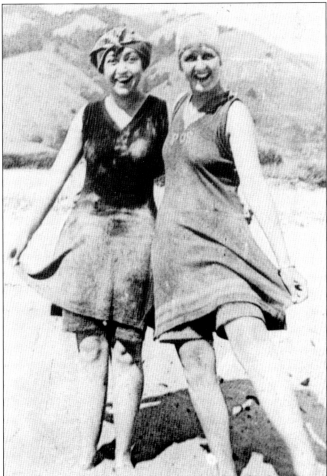

Hilarious bathing beauties are captured at a local beach in 1916.

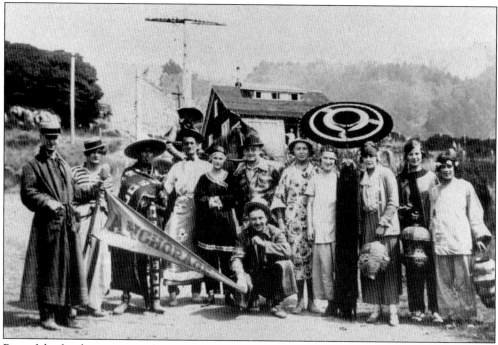

Part of the fun-loving group that hung out at "The Anchorage" is pictured here, with their hang out in the distance. This seems to be a parade with an original theme. This group was responsible for many parties and dances held in the 1920s.

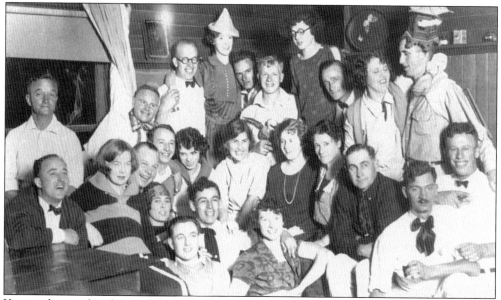

Yet another weekend party fills the Anchorage in the 1920s. Although privately owned, it was used as a "crash pad" for a select group of hikers who were known for their free spirits. Later a number of these people settled in Stinson Beach on a full time basis and were instrumental in the development of the town.

Three

THE COMMUNITY GROWS

Until the post office came to the town, Willow Camp was considered part of Bolinas since it was carved out of the old Rancho Baulenes grant. Here is an account of the birth of Stinson Beach by its second postmaster, Alice DeCamp Alger, found in the *Memorial and Remembrance Book* in Stinson Beach Community Chapel.

> *One day my father found a very important letter of his in the road, and it was rained on and open. He decided he was going to have a post office. After three years of writing letters and drawing diagrams, Washington gave its permission.*
>
> *Then a name. My father of course wanted Willow Camp, but the department said there were too many post offices in the state with the name of Willow . . . So, as this location was part of the Stinson Ranch, he asked for the name of Stinson Beach and it was granted.*
>
> *My older sister, E. Louise DeCamp, was first postmaster. The first post office was in a room under the porch of their house on the hill and they were told to start April 1, 1916 . . . I took the Civil Service examination, without competition, and received my commission on June 2, 1921. My husband and I built a flourishing business, a store and cottages to rent around the post office and it remained Fourth Class until World War II. The day after Pearl Harbor Day, the Coast Artillery moved in and operated the large searchlights on the hill at nights. They spent about a year and then the Coast Guard came in and were stationed there for the duration.*
>
> *The Greyhound Bus started operating and people who were employed at the Marin shipyards in Sausalito filled the town. The post office did such a big business that it was advanced to Third Class September 1, 1944.*

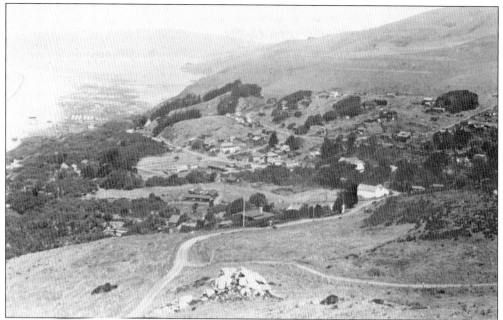

In the foreground of this 1920s Stinson Beach photo is the intersection of the Outside Road (Highway 1) and the Dipsea Trail (Panoramic Highway), and it is clear that the town is slowly growing up the hill. The Upton Camp tents can be seen on the beach and in the distance is the causeway, located at the south end of the lagoon.

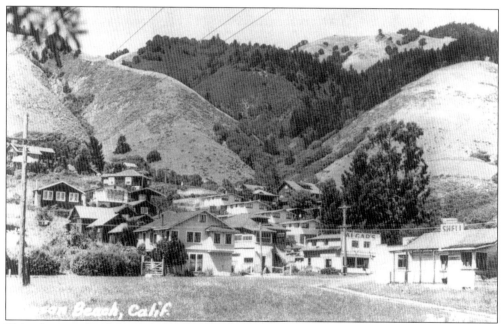

This photograph of the town in the late 1920s shows houses and cottages creeping up the hills of Stinson Subdivision #1. The four rental cottages marching up the hill behind Alger's were, and still are, Airey's rental cottages. The dark building farthest up the ravine in the center is the Anchorage.

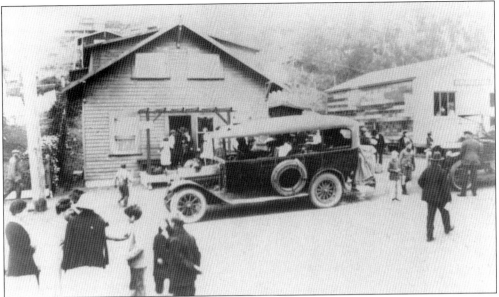

This photographer has captured a bustling summer day on Main Street (Highway 1) in 1921. It looks as if the bus in the foreground has just discharged a load of passengers. The building on the right was floated on a barge from Tiburon in three pieces. It served as the town's first barber shop and since the 1930s has housed a series of restaurants.

Commerce did come to Stinson Beach. What was once the hotel became Airey's Store. Owned by F.C. Algar, Stinson Beach Supply Company rented cottages, rooms, and tents and also served as the post office. Next door is another Algar enterprise, this one selling Red Crow Gasoline. Note that Highway 1 is still unpaved.

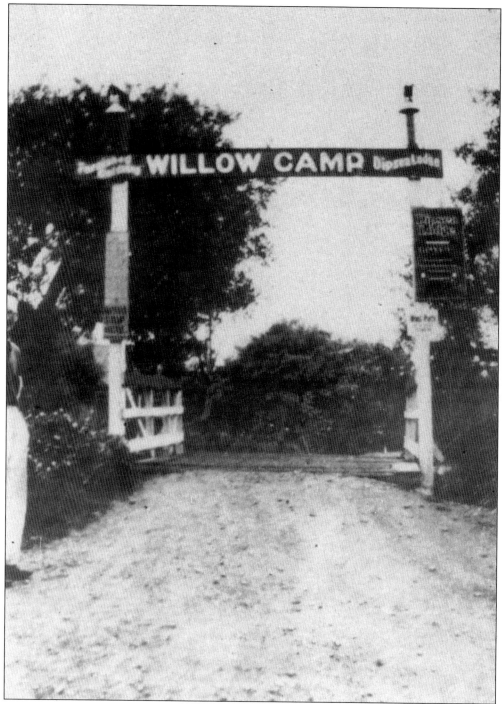

The sign to Willow Camp welcomes campers to the beach. Owner Newman Fitzhenry is seen on the left.

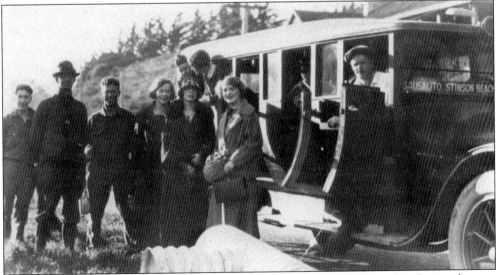

STINSON BEACH

The "beach that faces south," at the base of Mt. Tamalpais, on Bolinas Bay, easily accessible by auto stage from Sausalito, 9:05 a.m. and 3:35 p.m. daily, fare $1.00, or 15 miles scenic drive from terminal of Golden Gate Ferry, or 19 miles from Richmond-San Quentin Ferry, or via Napa and San Rafael from Sacramento; has 3 1-2 miles safe bathing, fishing, boating, hunting, hot sulphur baths, dancing, fine water and summer climate.

"Willow Camp," next to the beach; a grove of willows and alders, caters to auto and family camps at 20c per day, $1.00 per week, and $3.00 per month, per person. Picnicking 15c per person. Also, one, two and three-room cottages, completely furnished, electricity, at $7.50 to $20 per week; week-end rates, $1.00 and $1.50 per person.

"The building of the Golden Gate Bridge is converting Stinson Beach into a suburban residential territory. It is "the last West."

All provisions, including meat, fruit and vegetables, available at reasonable prices.

This is an all-year family resort.

PHONE
STINSON BEACH No. 1

N. L. FITZHENRY

STINSON BEACH
MARIN CO., CALIF.

(over)

WILLOW CAMP
FURNISHED COTTAGES
STINSON BEACH TOWNSHIP

Keep Out.

There are mixed messages on this calling card for Newman Fitzhenry's Willow Camp. This shows a front and back view, c. 1936.

Frenchy Gales poses here in 1929 with a group of his passengers. The Sausalito-Stinson bus was a thrilling ride between the two towns. Frenchy later left bus driving to work on the Golden Gate Bridge.

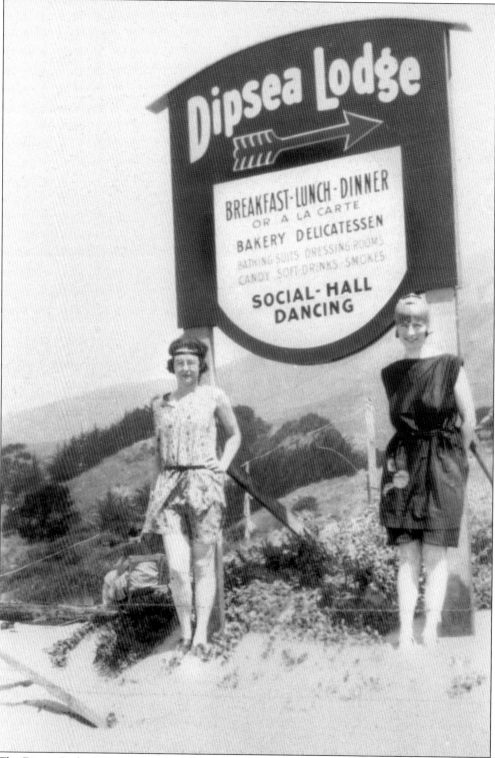

The Dipsea Lodge Sign is graced by local sea nymphs in the 1920s.

The pristine white sand, here surrounding the Dipsea Lodge cabins in 1930, has always been a major attraction for visitors from all over northern California.

Shown here is Hattie Greene, who hiked over to Stinson Beach on a regular basis in the 1920s. She later settled here, as did her sister Ruth Miller, and worked as the secretary for both the fire and water departments.

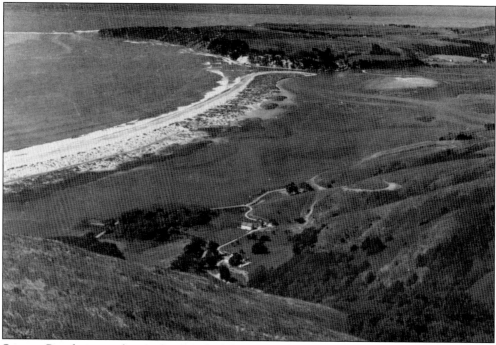

Stinson Ranch sits at the northern end of the town adjacent to the one-room Stinson Beach School, which was built on land donated by the Stinson family.

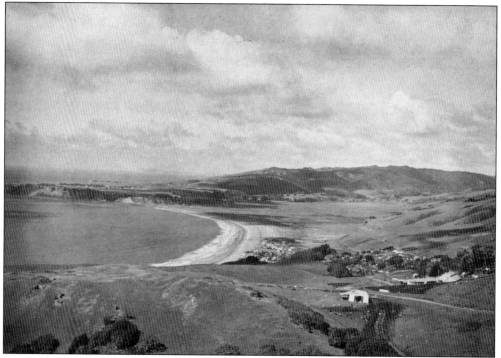

In this view of Stinson Beach, Bolinas Bay, and the lagoon, Bolinas Mesa is visible in background and the White Gate Ranch, which flourished into the 1970s, is in the foreground on the right.

This view of the Easkoot House in 1930 was taken after extensive remodeling and re-landscaping. Newman and Eve Stinson Fitzhenry bought the Easkoot house in 1911; they also took over Willow Camp and built the Dipsea Lodge on the beach. They were both very influential in the town.

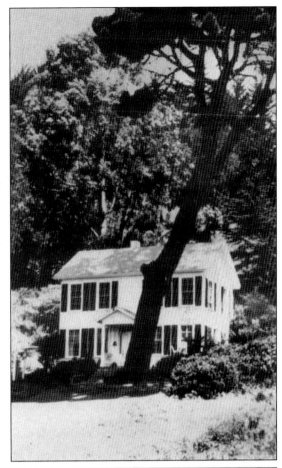

The tents are gone and cottages take their place on the Calles and Patios, off Calle Del Arroyo, formally known as the Charles Robinson Tract.

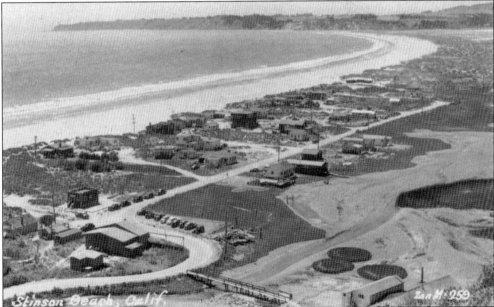

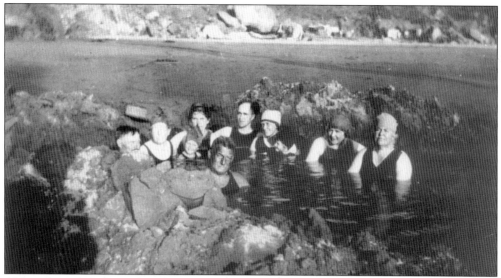

Although earthquakes reduced its flow over the years, Sulfur Hot Spring could still be found near the farthest rocks at the south end of the beach at minus low tide. Bathers first dig a large hole in the sand and mound it high enough to stop the invading cold tide water. Then they sit back and enjoy the heated water.

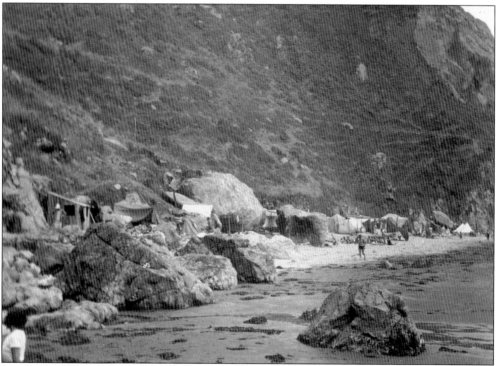

During the Great Depression homeless people lived in lean-tos made out of driftwood and tents on the beach at Steep Ravine south of town. Not much is known of this settlement, which was destroyed when the State of California rolled huge boulders down on it in the process of widening Highway 1.

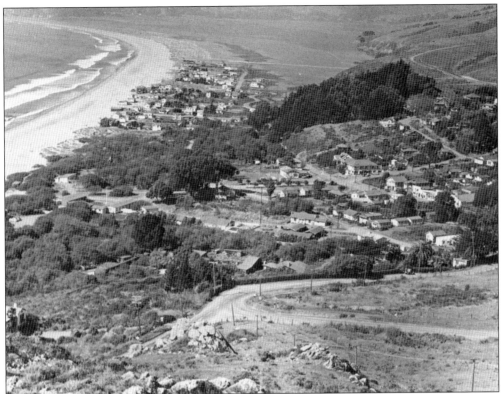

Stinson Beach is shown here in the late 1930s. The town continues to grow in part because both roads going over the hill are now paved. In the foreground is the junction of Panoramic Highway and Highway 1, known locally at that time as the "Outside Road."

Van Osten's Casino is shown here in the 1930s. Its front, which faced the ocean, was one story. Day parking cost 25¢ per car but was free to cottage guests.

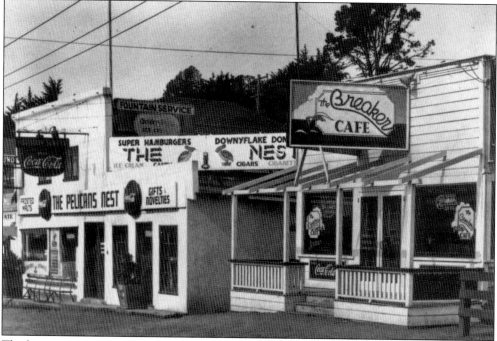

The business section of the village is shown here in the early 1940s. Highway 1 through town was still unpaved. The Breakers is still a restaurant known today as the Sand Dollar. The main part of the Pelican's Nest is now Oceanic Realty, while the small annex to the right is currently a lawyer's office.

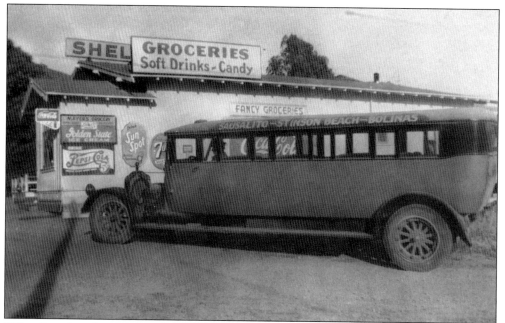

TThe Sausalito–Stinson Beach–Bolinas bus is shown here stopped in front of the Bungalow Grocery Store, which flourished for many years. After a brief life as a pizza parlor, it became the Stinson Beach Grill run by the Horton family.

The Sea Side Restaurant, pictured here in 1940 on the west side of Shoreline Highway, was a local favorite. This building now houses Stinson Beach Books, owned and operated by Anne Rand. Its logo reads, "The only book store on the San Andreas Fault between Dog Town and Jimmy's Gulch."

"SBFD, Pol D, WELCOME Babes" is written on this youth's car, parked in front of the Sea Beach Hotel. The round sign on the building reads, "Meeting Hall, Progressive Club of Stinson Beach." The meeting hall, memorialized on this 1940s postcard, was on the first floor of the Sea Beach hotel operated by William and Louise Airey and was, by this time, functioning as the community center. The Progressive Club, established in 1936, oversaw many civic developments.

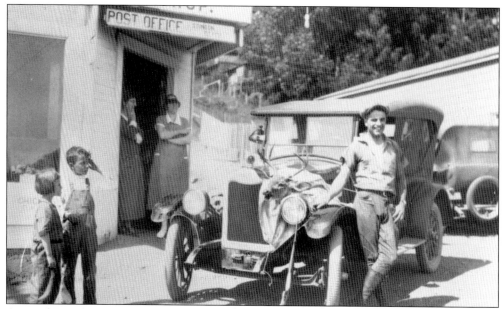

A proud Frenchy Gales shows off a deer strapped to the fender of his car. A rifle is propped up next to the car, leading one to believe he shot it, rather than hit it, while driving the bus between Sausalito and Stinson Beach. A popular man about town all of his life, Frenchy later married Frank Airey's widow, Marjorie.

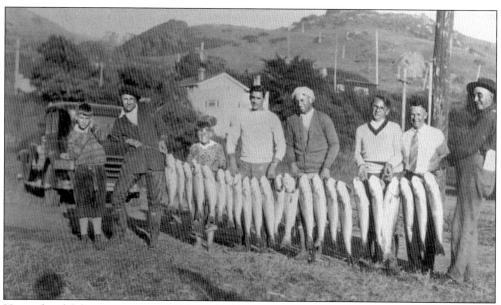

Happy local fishermen pose, c. 1933, with their catch of striped bass, which were abundant at the Bolinas Lagoon channel. Unfortunately, this is not the case today.

Frenchy Gales, along with his step-grandson Michael Griffin, pose with "the largest striped bass of all" in the 1940s. Note the bottle cap collection on Michael's shirt—a popular fad of the day.

Built by Thomas Kent in the 1920s, Sea Downs, seen here in 1946, provided a snack bar and rental cabins for vacationers. It was torn down in 1956 when the beach became a state park.

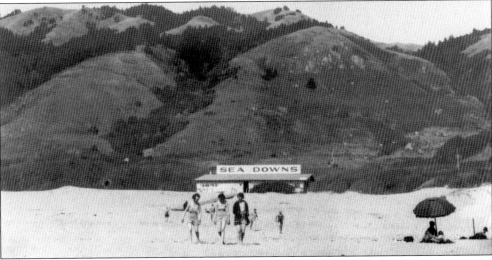

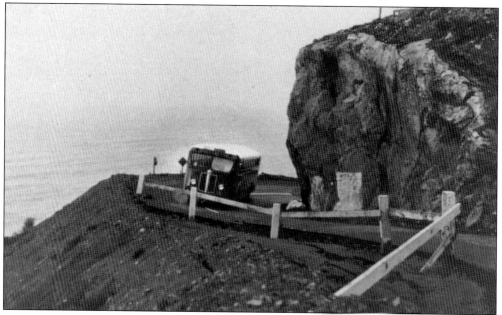

An empty Tamalpais High School bus rounds a sharp corner on the "outside road," the locals' name for Highway 1, on its way to Mill Valley.

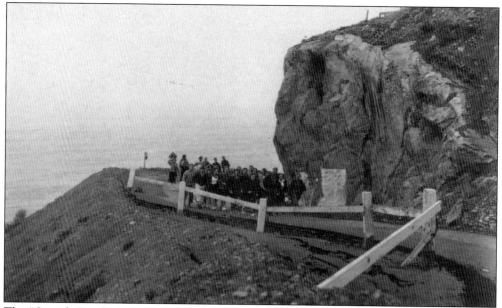

The "Outside Road" at the corner above the Steep Ravine was considered to be so dangerous that students had to get off the bus and walk around the corner before reboarding, as seen here in the 1940s. When the state widened the road this hazard was removed.

This guard dog is being trained by a member of the Coast Guard's Stinson Beach patrol in 1942. The beach was also patrolled by men on horseback.

On the night of December 7, 1941, the military rolled into the town and were quartered in every available empty house. Stinson Beach was thought to be the most likely place for a Japanese landing. Citizens took shifts of three hours each, listening for Japanese planes. A single bomb washed up on the beach and was detonated in 1942. In accommodating the overflow of Sausalito shipyard workers, the population of Stinson Beach multiplied dramatically.

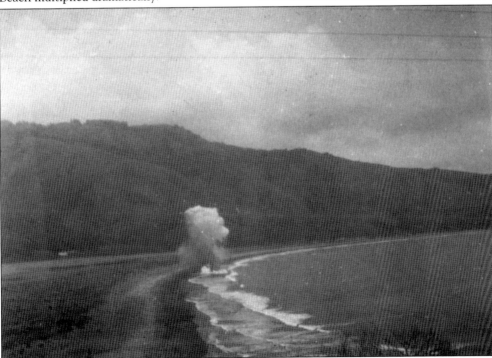

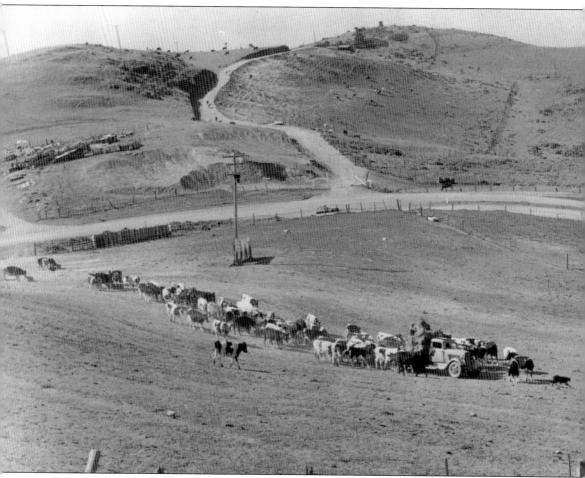

Cows are fed hay from the back of a truck on White Gates Ranch. The road leading off the Panoramic Highway was where the military built large bunkers at the outset of World War II. Although they still stand today, the bunkers have been sealed shut to keep out trespassers.

Three
PROGRESS TAKES PLACE

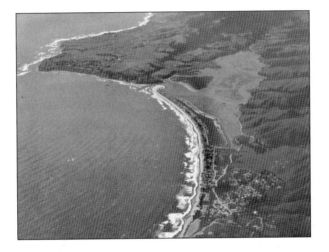

The last act of philanthropy by the direct descendants of Nathan Stinson's family was to donate the land for Stinson Beach Community Center complex. Sally Cothrin, who was the Stinson Beach correspondent for *Bayview Press* in Point Reyes, wrote this in the *Memorial and Remembrance Book* in Stinson Beach Community Chapel.

Eve Stinson Fitzhenry passed away Saturday night, Jan. 8th, in Marin County. On the afternoon of that day, under a cold winter sun, the first spadefulls of earth were dug by volunteer workers toward building the Community Center in Stinson Beach, Eve Fitzhenry's dream and goal during the last full years of her life.

With her sisters, Mrs. Lillian Hensill and Miss Maude Stinson, Eve Fitzhenry signed the gift deed that turned the wooded acres with their singing mountain stream to the citizens of her beloved town. At her home was shaped the charter for the Center. She spent days poring over plans for an edifice that would rise above the rustic setting.

Though Eve did not stay to see the completion of her dream, the slow building, timber by timber, of the Community Center, will be a living memorial to her. . . And so long as the stream sings through the wooded acres, her friends will always see her walking toward them: the petite, trim figure in pastel slacks, the garden shears and trowel showing above the basket on her arm, the blue eyes under an aura of white hair; the sudden, puckish smile of THE FIRST LADY of Stinson Beach, EVE FITZHENRY.

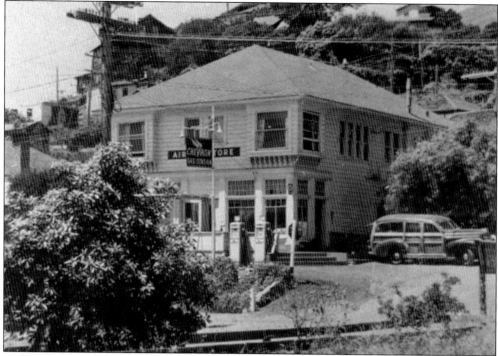

Airey's Store had gas pumps in the front before it was totally remodeled. The "woody" station wagon, owned by Margerie and Frank Airey, was used as an ambulance by the volunteer fire department. The fire truck was parked on the hill above the store so it could be rolled down in the event that it did not start.

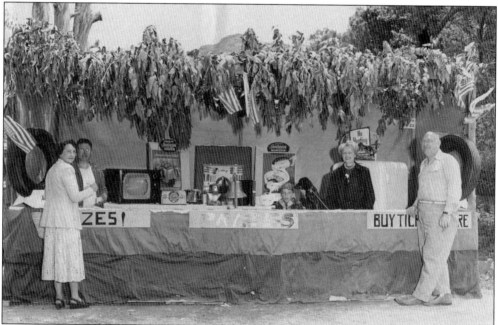

A series of Fourth of July carnivals were held to raise money to build Stinson Beach's community center complex. This 1948 picture features a television, a hot item at that time.

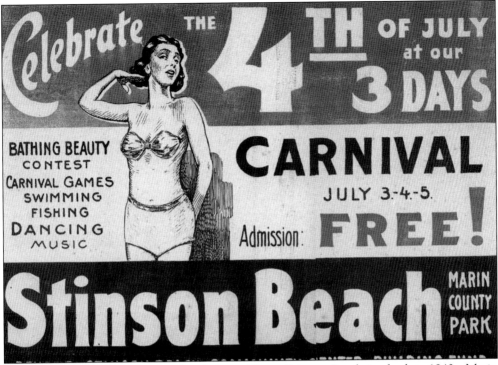

This "hot" Fourth of July poster lured the public to Stinson Beach in the late 1940s. Marin County Park, where this carnival was held, is now the Golden Gate National Recreation Area. One three-day carnival in the late 1940s earned enough money to buy materials for the firehouse.

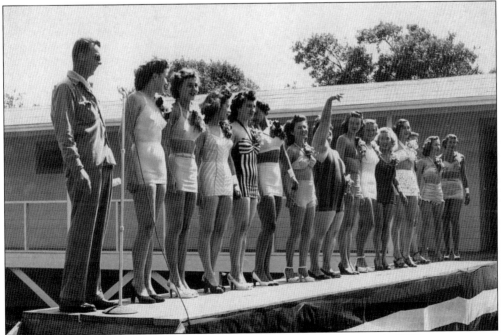

Bathing beauties line up for the Fourth of July Carnival Beauty Contest in 1950.

The Stinson Beach Fire Department was the first of the three community center buildings completed. It has since been modified three times to hold more modern fire-fighting equipment. Although this remains the main firehouse, a second house was needed in the 1980s to house additional equipment. It was built on the Calle Del Arroyo by volunteers on land leased from the county for 99 years for $1—quite a bargain!

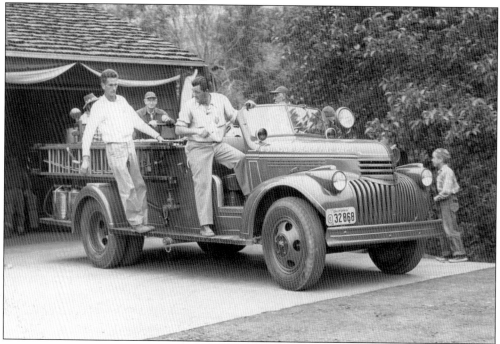

A fire truck rolls out for the firehouse dedication in 1949. Since that time the 40-member group of volunteers has played an important part in the history of the town.

The Community Center Hall was completed and dedicated in 1953. In the old barn-raising spirit, local residents volunteered to construct the Stinson Beach Community Center buildings. The three structures were built on land donated by the Stinson family.

This chapel building was dedicated in 1963, the last of the three community center buildings constructed. A bell tower was added in the 1990s.

This view of the sandspit with Bolinas Mesa in the background was taken c. 1953. Note the houses on the sandspit, the beginning of Seadrift.

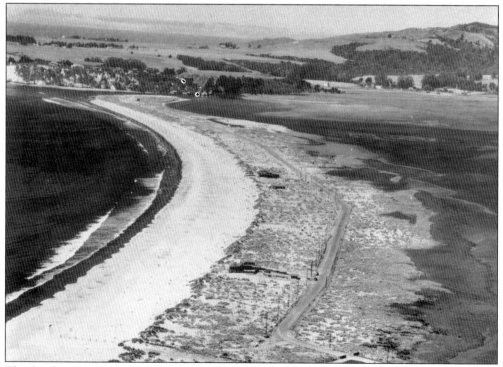

The first houses rise on Seadrift Road in the 1950s. What a desolate-looking place. Who could have imagined that this area would be filled with houses worth millions of dollars?

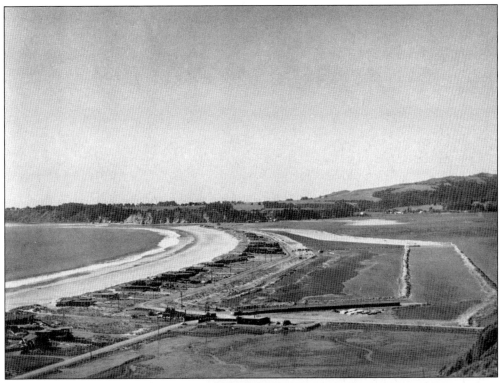

This photograph shows dredging work underway for the manmade lagoon and the construction of Dipsea Road.

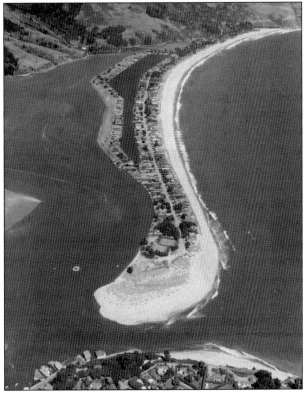

This bird's-eye view of the Seadrift Subdivision was taken in 1990. It is nearly fully developed with over 350 homes that are the most expensive in the area.

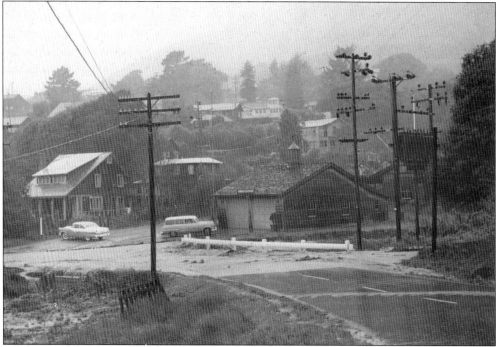

The great storm and floods of 1956 howled in just after the community center was completed. Easkoot Creek, which has been moved to provide more land for the center, jumped its banks, sending mud through the building. Before it subsided, the waters took out the bridge on Highway 1 as well.

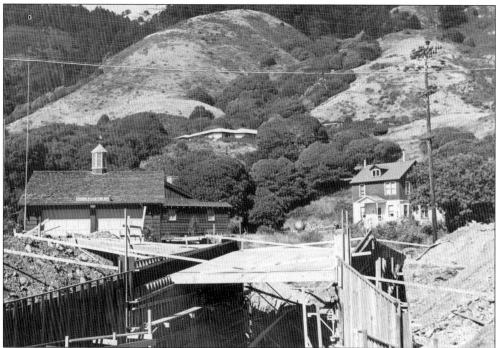

A year after the devastating storms and floods of 1956, Cal Trans finally rebuilt the bridge.

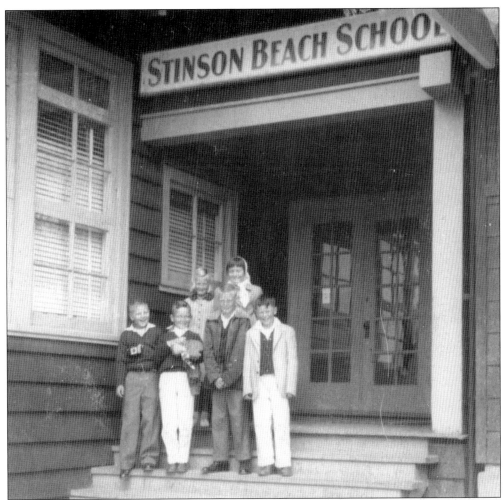

The Stinson Beach School, a one-room redwood building, painted red with white trim, was built in 1917 on a nine-acre site donated by the Stinson family. These children were photographed in front of the school in 1950.

Louise Airey and Mildred Sadler, who team-taught at the school for many years, are seen here in 1959. Both were very active civic leaders and with their husbands, William Airey (who served as fire chief and community center board chair) and Lester Sadler (who served on the Progressive Club board and as the community center board chair), became instrumental to the building of Stinson Beach as we now know it.

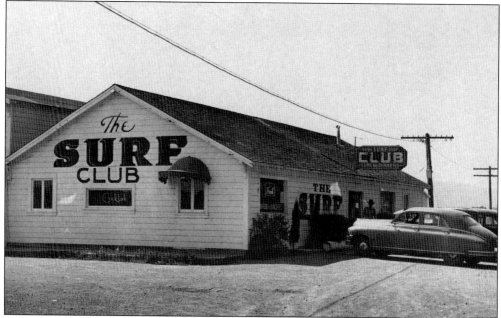

Located on Highway 1 on the north side town, the Surf Club was leased to the Coast Guard for a barracks during World War II. After the war, the building changed hands at least four times before it was gutted by fire in the mid-1980s. It was finally torn down in 1992 and replaced by the Stinson Beach/County Water District offices.

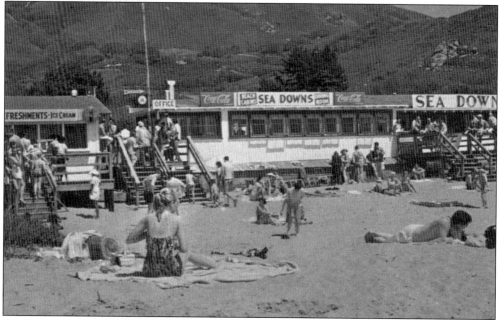

Sea Downs is captured here on a 1950s postcard, which states the following on its reverse side: "Sea Downs on the Pacific located just a few miles north of San Francisco on the Blue Pacific. This popular resort offers a beautiful beach with swimming, surf fishing, clamming, cottages and good food. Operated by Larry and Nina Wold, Chet and Dorothy Mayfield." Dorothy was also the Stinson Beach postmaster through her retirement in the late 1980s.

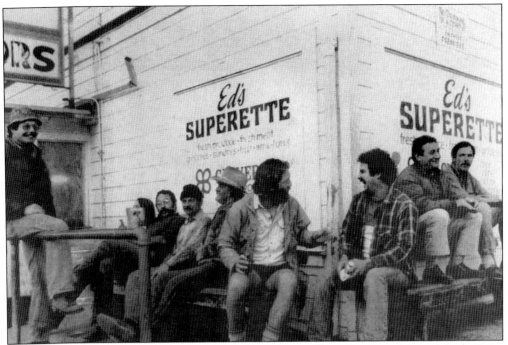

Locals still hang out in front of the store, watching the world pass by. From left to right are John Perry, Wendy Crowell, Ben Chollar, Chuck Abercrombie, Steve Lewis, Bill Stage, Ronnie Whilhelm, Luigi Alfano, and Kendrick Rand.

The Fourth of July carnival continues to be a fundraising event for the community center in the 1990s. Celeste LaPrade Washington, in the foreground, served as president for many years.

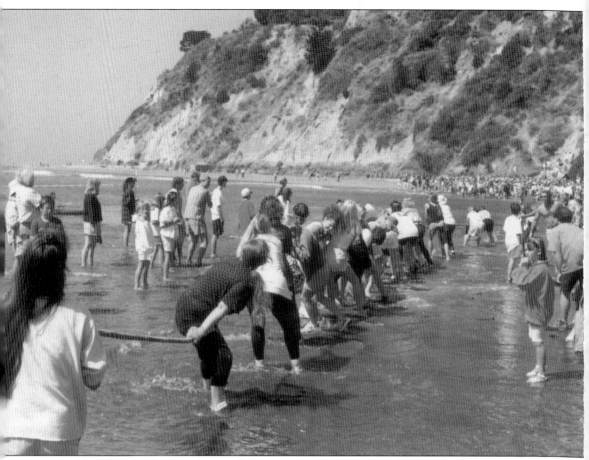

Held at the mouth of the lagoon that separates the two towns, the Fourth of July Tug of War is a wonderful tradition, playfully pitting Stinson Beach against Bolinas. Unfortunately, both the men's and women's teams from Bolinas usually win bragging rights with their hard-fought victories.